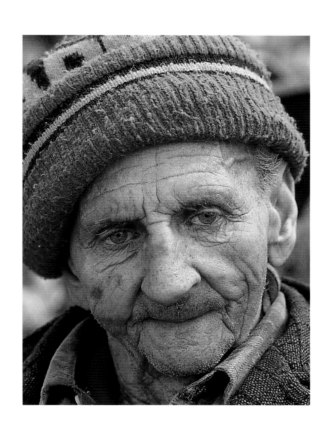

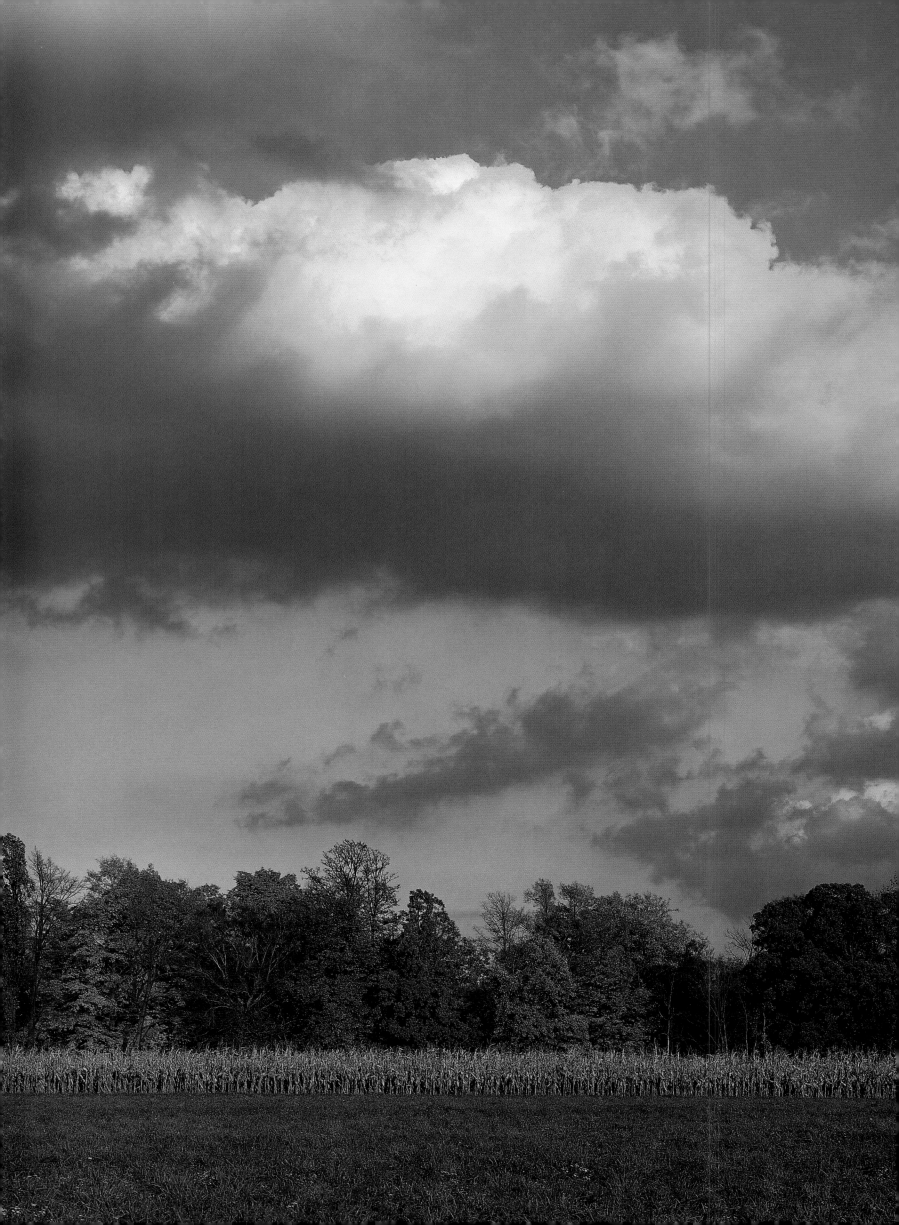

To Ruth Ellen,
may you continue to be
inspired by the beauty
of God's creation!
Darryl Jones

INDIANA II

PHOTOGRAPHY BY DARRYL JONES
ESSAY BY JAMES ALEXANDER THOM

Best wishes from one of the natives
Thom

GRAPHIC ARTS CENTER PUBLISHING®

To my wife Nancy, my daughter Hannah, my son Aaron, my daughter-in-law Shana,
my parents Mr. and Mrs. William B. Jones Jr., and my mother-in-law Mrs. William C. Grepp.

DARRYL JONES

International Standard Book Number 1-55868-294-5
Library of Congress Catalog Number 96-76288
Photographs © MCMXCVI by Darryl Jones
Essay and captions © MCMXCVI by James Alexander Thom
No part of this book may be copied by any means
without written permission from the Publisher.
Published by Graphic Arts Center Publishing Company
P.O. Box 10306 • Portland, Oregon 97210 • 503/226-2402
President • Charles M. Hopkins
Editor-in-Chief • Douglas A. Pfeiffer
Managing Editor • Jean Andrews
Photo Editor • Diana S. Eilers
Designer • Robert Reynolds
Production Manager • Richard L. Owsiany
Cartographer • Ortelius Design
Book Manufacturing • Lincoln & Allen
Printed and Bound in the United States of America

Half Title Page: Having farmed, acquired land, and swapped antiques all his life, Floyd Stahl looks over his corner of the Indiana hills with a bemused, canny gaze. *Frontispiece:* Fine hardwood forests and Indian corn grew side by side for thousands of years before explorers from Europe strayed into this fertile Middle Ground.

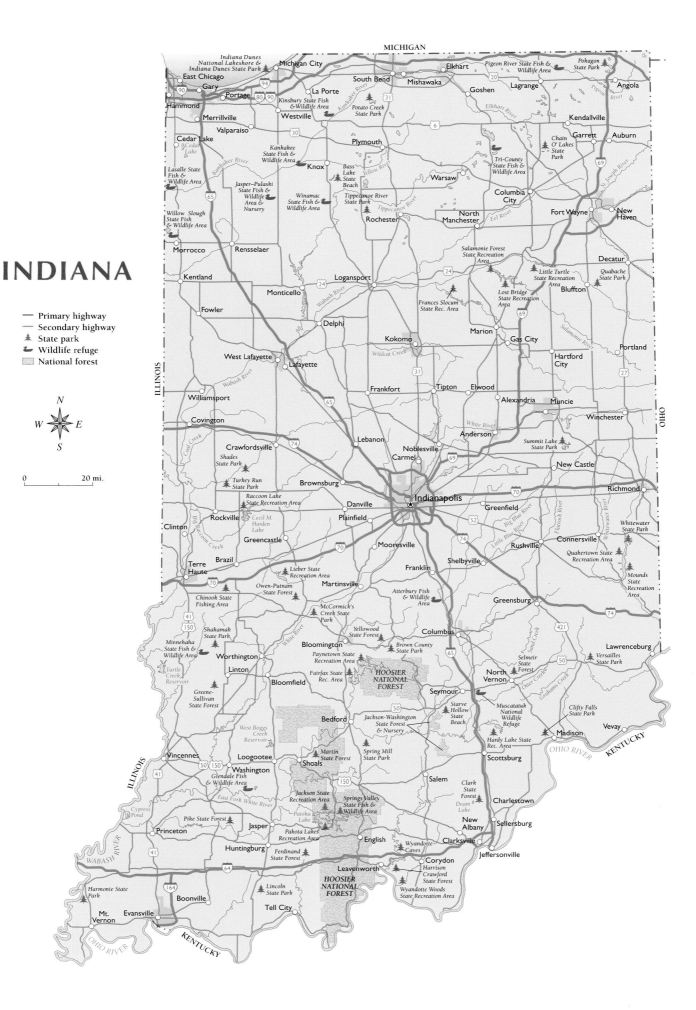

INDIANA

- —— Primary highway
- — Secondary highway
- ⚐ State park
- ⚓ Wildlife refuge
- National forest

N W E S

0 20 mi.

MICHIGAN

Indiana Dunes National Lakeshore & Indiana Dunes State Park
East Chicago
Gary
Portage
Hammond
Merrillville
Valparaiso
Cedar Lake
Cedar Lake
Lasalle State Fish & Wildlife Area
Willow Slough State Fish & Wildlife Area
Morrocco
Kentland
Fowler
Williamsport
Covington

Michigan City
La Porte
Kinsbury State Fish & Wildlife Area
Westville
Kankakee State Fish & Wildlife Area
Knox
Jasper–Pulaski State Fish & Wildlife Area & Nursery
Winamac State Fish & Wildlife Area
Rensselaer
Monticello
Delphi
West Lafayette
Lafayette

South Bend
Mishawaka
Potato Creek State Park
Plymouth
Bass Lake State Beach
Tippecanoe River State Park
Rochester
North Manchester
Logansport

Elkhart
Goshen
Pigeon River State Fish & Wildlife Area
Pokagon State Park
Angola
Lagrange
Kendallville
Garrett
Auburn
Chain O' Lakes State Park
Tri-County State Fish & Wildlife Area
Warsaw
Columbia City
Fort Wayne
New Haven
Salamonie Forest State Recreation Area
Little Turtle State Recreation Area
Quabache State Park
Decatur
Bluffton
Lost Bridge State Recreation Area
Frances Slocum State Rec. Area
Marion
Gas City
Hartford City
Portland

ILLINOIS

Kokomo
Frankfort
Tipton
Elwood
Alexandria
Muncie
Winchester
Anderson
Summit Lake State Park
Noblesville
Carmel
New Castle
Richmond
Greenfield
Whitewater State Park
Connersville
Quakertown State Recreation Area
Mounds State Recreation Area

Crawfordsville
Shades State Park
Turkey Run State Park
Raccoon Lake State Recreation Area
Rockville
Cecil M. Harden Lake
Greencastle
Clinton
Brazil
Terre Haute

Lebanon
Brownsburg
Danville
Plainfield
Mooresville
Indianapolis
Franklin
Shelbyville
Rushville
Greensburg
Lawrenceburg
Versailles State Park

Lieber State Recreation Area
Owen-Putnam State Forest
Martinsville
Atterbury Fish & Wildlife Area
Columbus
Selmeir State Forest

Chinook State Fishing Area
McCormick's Creek State Park
Yellowood State Forest
Brown County State Park
Bloomington
Paynetown State Recreation Area
Fairfax State Rec. Area
HOOSIER NATIONAL FOREST
North Vernon
Clifty Falls State Park
Madison
Vevay

Minnehaha State Fish & Wildlife Area
Shakamak State Park
Worthington
Linton
Bloomfield
Greene-Sullivan State Forest
West Boggs Creek Reservoir
Bedford
Jackson-Washington State Forest & Nursery
Starve Hollow State Beach
Seymour
Muscatatuck National Wildlife Refuge
Hardy Lake State Rec. Area
Turtle Creek Reservoir

Vincennes
Loogootee
Washington
Glendale Fish & Wildlife Area
Martin State Forest
Shoals
Spring Mill State Park
Salem
Scottsburg
Clark State Forest
Charlestown
Deam Lake

Cypress Pond
Jackson State Recreation Area
Springs Valley State Fish & Wildlife Area
Patoka Lake
Pakota Lakes Recreation Area
English
New Albany
Sellersburg
Clarksville
Jeffersonville

Pike State Forest
Princeton
Jasper
Huntingburg
Ferdinand State Forest
Wyandotte Caves
Corydon
Harrison Crawford State Forest
Wyandotte Woods State Recreation Area
Leavenworth
HOOSIER NATIONAL FOREST
Lincoln State Park

Harmonie State Park
Boonville
Mt. Vernon
Evansville
Tell City

OHIO

WABASH RIVER

OHIO RIVER

KENTUCKY

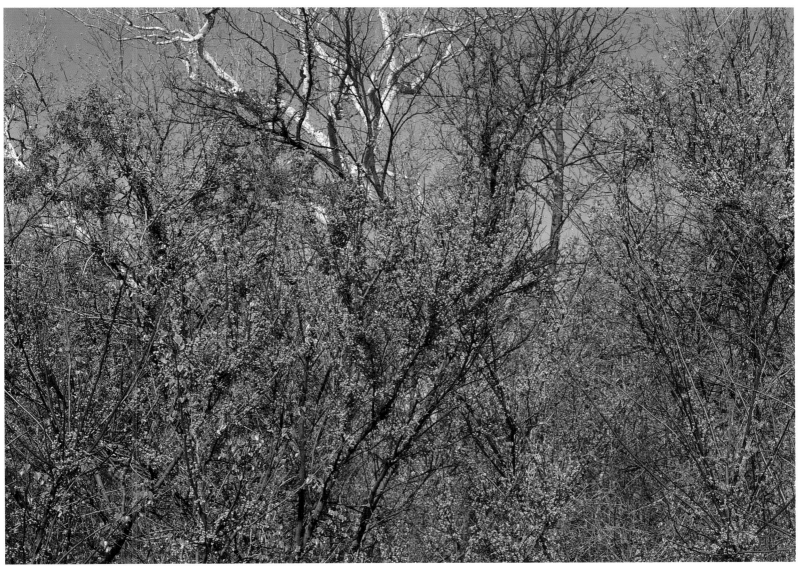

◁ Testimony to woodworking skills and harmonious sense of design, this old barn overlooks the Ohio River in Switzerland County, settled by Swiss wine-growers who cultivated wine grapes on the bluffs.
△ In the midst of Indianapolis residential neigh-borhoods, Mother Nature makes a secret garden of native redbud and sycamores along a creekbed.
▷▷ Parke County's autumn Covered Bridge Festival guides travelers to the thirty-four spans remaining of the fifty-seven built in the nineteenth century.

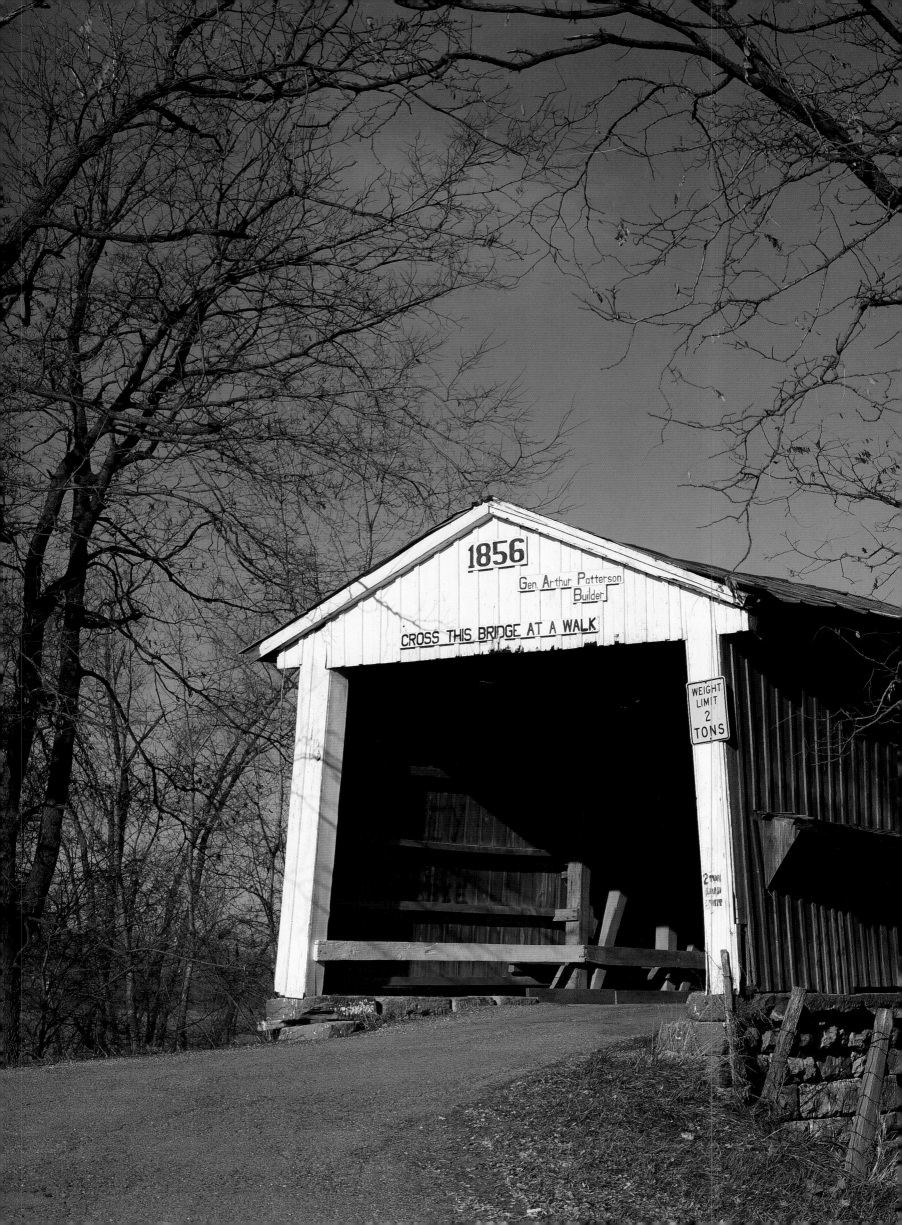

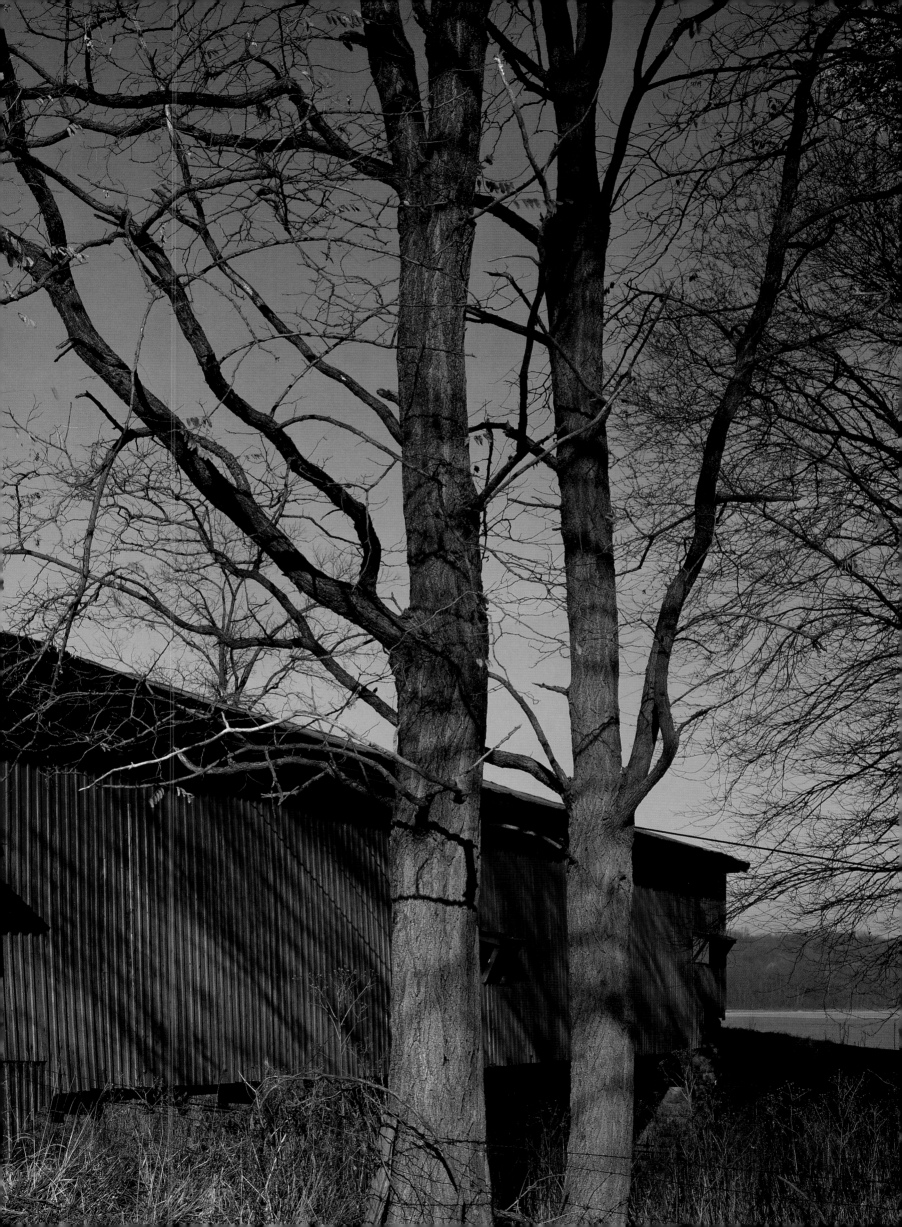

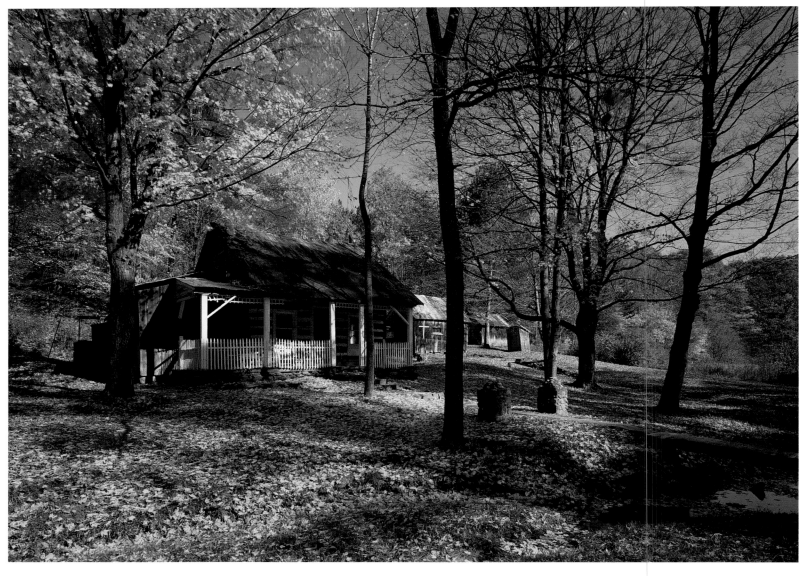

△ Occupied by generations of the family that built
it, this log cabin on State Highway 135 is represen-
tative of the rustic dwellings found in Brown County,
said to have more log cabins per capita than any
other county in the United States. ▷ For sixty years,
no building in Indianapolis could surpass the 284-
foot Soldiers and Sailors Monument, but skyscrapers
now dwarf the ornate limestone shaft. The cool,
spilling fountains around its base soften the noise
of traffic at the capital city's renovated hub.

10

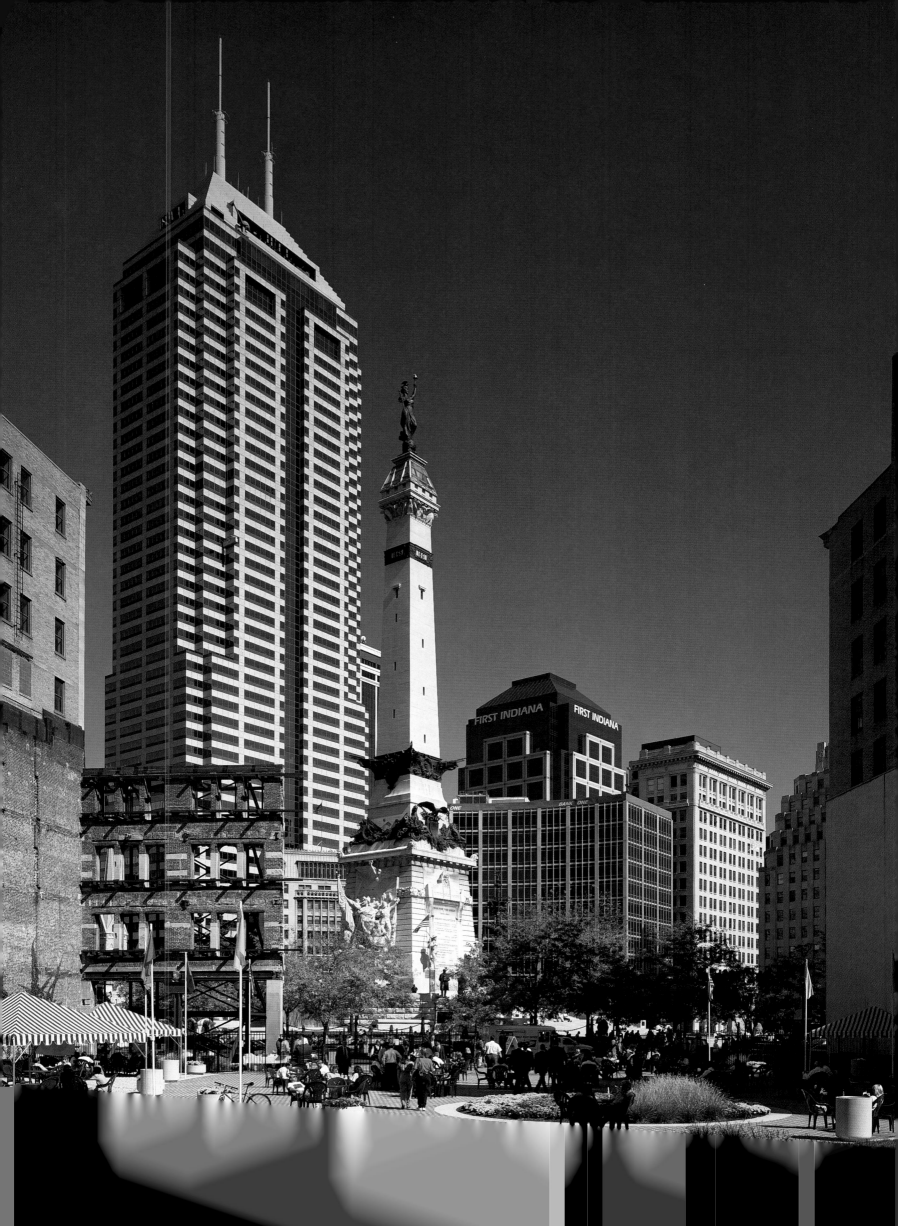

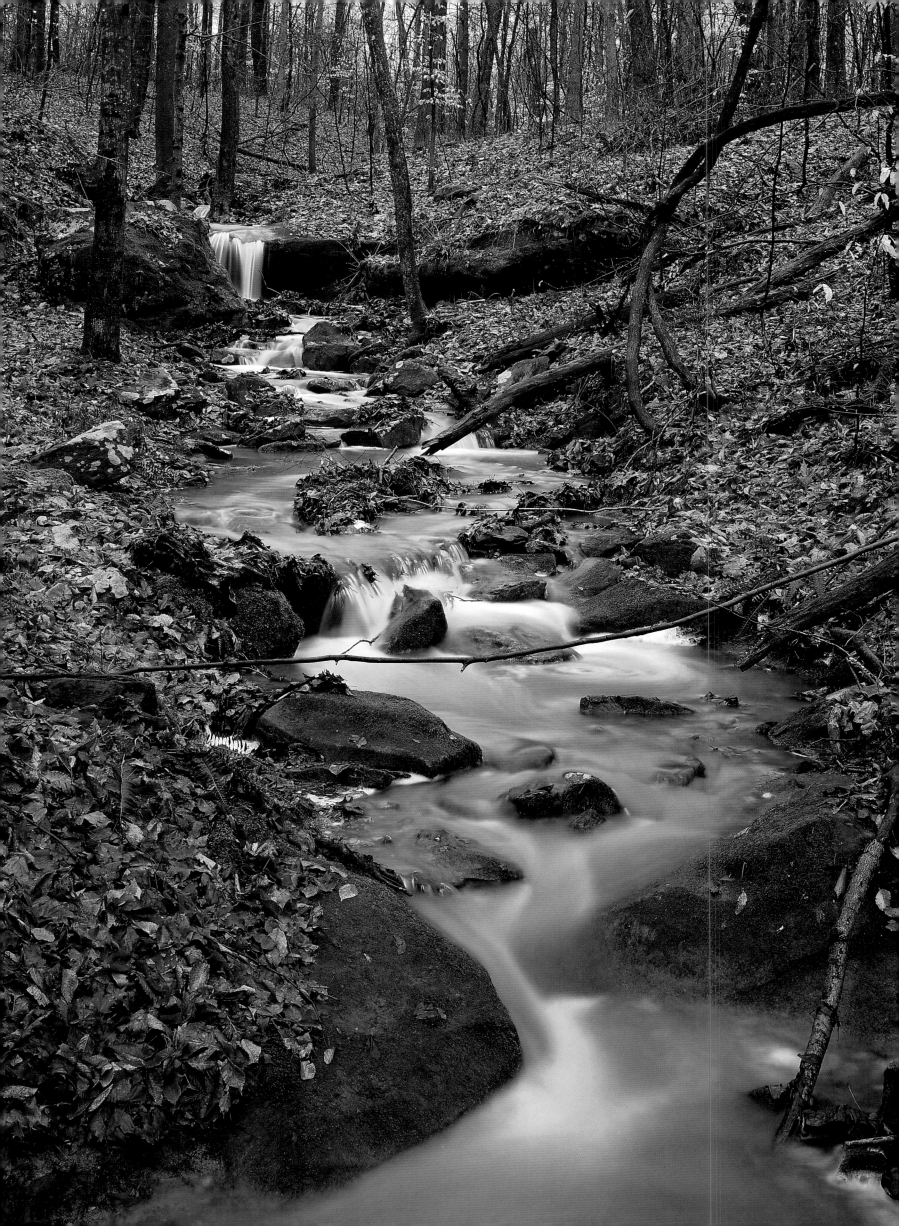

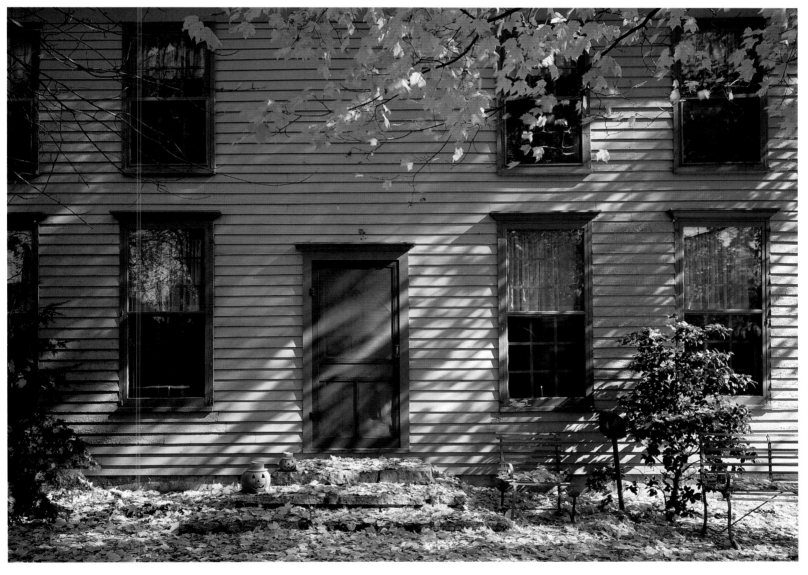

◁ Running water erodes limestone in the endless sculpturing of Southern Indiana's rugged terrain, which was bypassed by Ice Age glaciers. Hardwood timber and quarried building stone were early products of this hardscrabble region. △ Jack-o'lanterns and autumn foliage emblazon the weathered siding of a well-preserved early Zionsville home. The town stands in the rich farmlands of Boone County, named in 1830 for Daniel Boone, who once was a government surveyor in the vicinity.

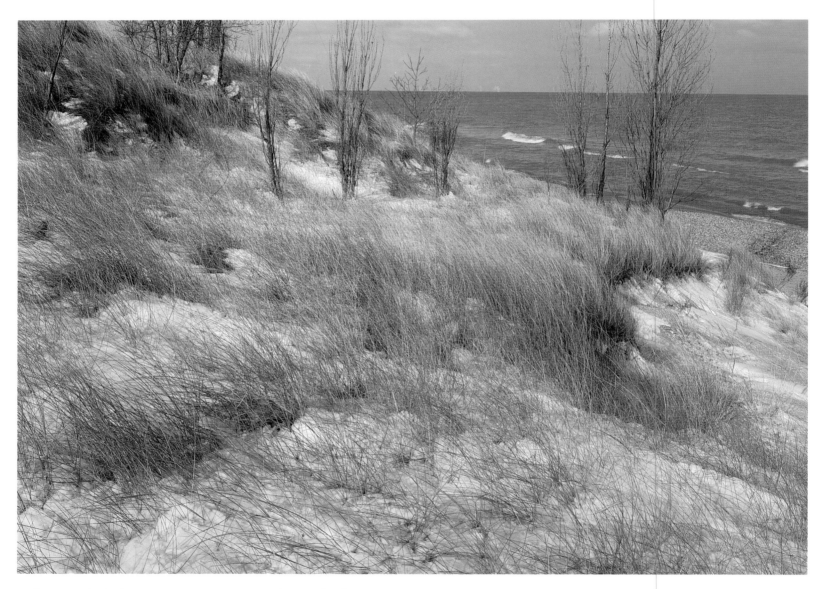

△ Snow and windswept marram grass cover the sands of
the Indiana Dunes National Lakeshore, continuously shaped
by winds off Lake Michigan. The high dunes and bordering
glacial bogs support an astonishing diversity of ecosystems
and rare plants. Until eighty years ago when a "save the
dunes" movement gained momentum, both ecosystems and
plants were threatened with extinction. ▷ Even stark mid-
winter fails to obliterate all the food and beauty provided
by Indiana's temperate climate and rich soils. Birds feed
year-round on winterberries and other fruits and seeds.

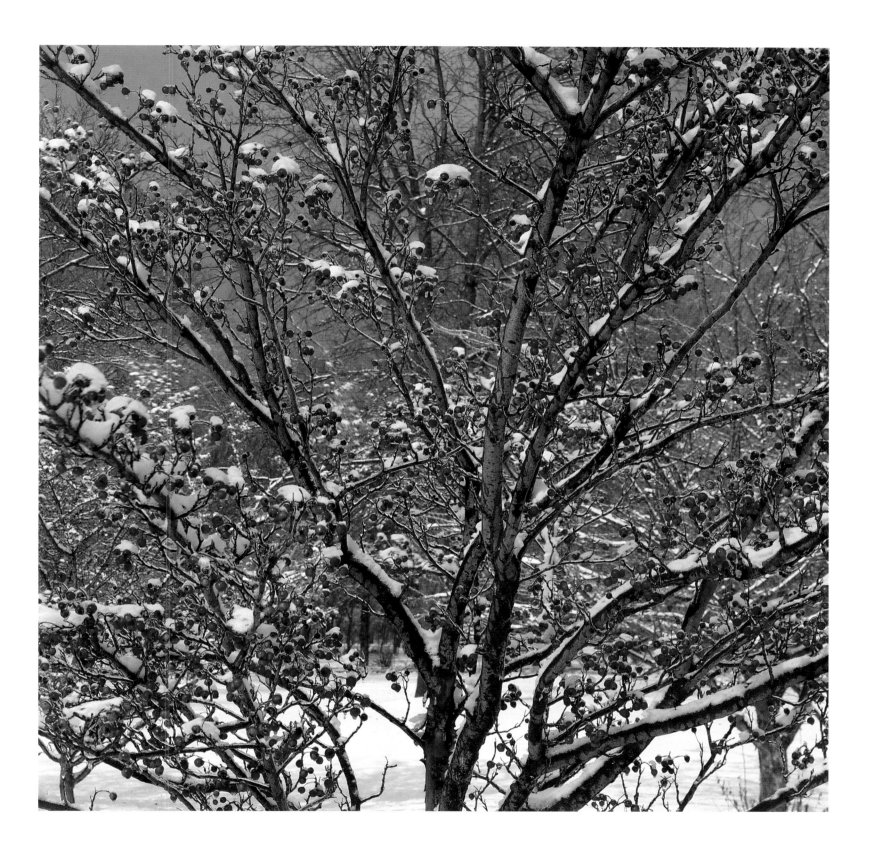

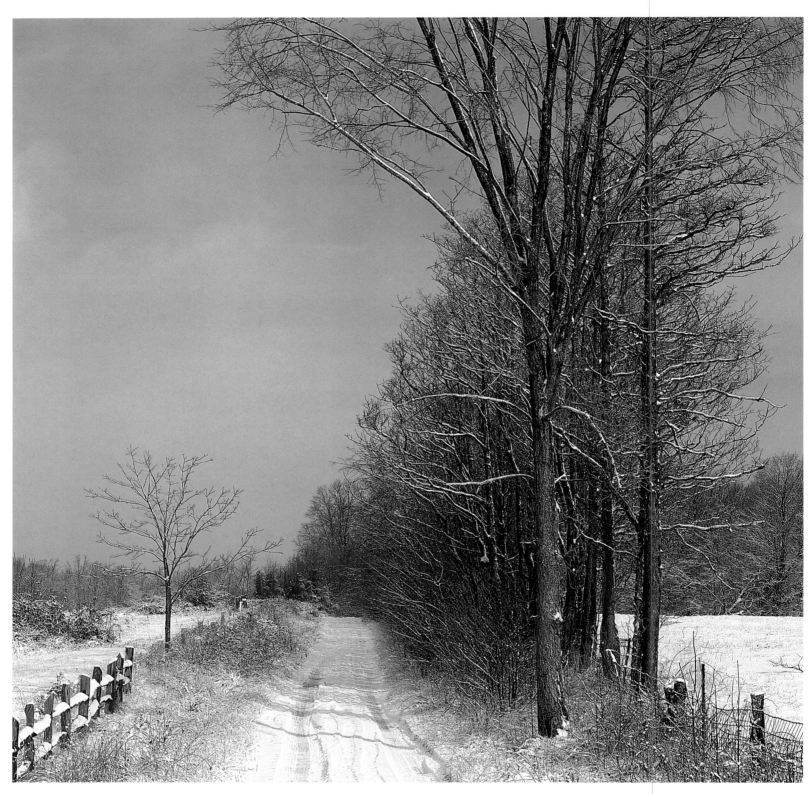

△ Roads, fences, pastures, and fields are man's signatures upon a land that was almost entirely covered with forests two centuries ago. Terrified and oppressed by shadowy forests, the early settlers cleared them all, drained the swamps, and tamed the country for their crops and livestock, often using piles of stumps and branches for fences. Trees too big to cut down were girdled, to die and fall, the ground plowed around them until they rotted. Most main highways of today follow old Indian trails.

16

INDIANA
by James Alexander Thom

About twenty years ago, a southern Indiana farm wife leafed through her new copy of *National Geographic,* flipping forward from the back pages as many magazine readers do, when her gaze fell upon a glorious two-page color photograph showing corn rows curving along a creek valley between steep hills emblazoned with autumn foliage, all diffused by luminous morning mist.

She sighed and said, "Oh, I wish I lived in a lovely place like that!" Then she flipped to the next page, noticed that the article was about her own Indiana hill country, and exclaimed, "Wow! I *do* live in a lovely place like that!"

The point is that nobody, even Hoosiers, would much expect to see the Hoosier state in a magazine known for showing far-away and exotic places.

Even a chauvinistic Hoosier must admit Indiana is not exotic. It is a low-profile kind of a state. Some cross-country travelers say they know they must have gone through Indiana because, according to the map, the highway goes across it, but they did not *notice* Indiana. It is part of that vast, unspectacular stretch, between the Alleghenies and the West, that a fast modern traveler tends to lump together as "Ohiowa."

But the nice thing about a low-profile place is that it is sincerely and profoundly proud of anything it has to be proud of; while Indiana has no mile-high mountains or rocky seashores, no palm-lined harbors or world-class metropolises, it does have so many things to be proud of that a Hoosier, if called upon to brag, will hardly know where to start. A Hoosier can boast of the state's pivotal role in the history of the new nation, of its superlative farmland, of its coal mines and steel making and manufacturing, of its astonishing number of famous writers, composers, inventors, heroes, scientists, movie stars, reformers, and athletes. He can brag that it raised Abe Lincoln, provided most of the building stone for Washington, D.C.'s public buildings, and that it was the cradle of the automobile industry.

Hoosiers even tell of their state's dubious distinctions, such as its famous outlaws, like John Dillinger; its huge Ku Klux Klan membership; its capricious, maddening weather highlighted by an average of twenty-three lethal tornadoes a year; and, worse yet, that it had, at Terre Haute in 1910, America's first pay toilets.

Indiana, for a number of reasons, has long been considered the true heartland of America. The westward-creeping "center of population" of the United States was for some sixty years within the borders of Indiana, before moving on to points in Illinois.

But the notion of heartland is more than just location; it is also a sort of ontological concept. Hoosiers tend to feel that they stand at the moral center of their nation, that they are the ethical and cultural median. For decades, marketing analysts have used Indiana as a primary test market, in the belief that there is something unshakably "average" about its people, that Hoosiers are neither *avant-garde* nor truly backward.

How does a state become a classic heartland? How do a state's citizens arrive at a cultural and moral center? Only a fool or a Hoosier would try to explain that, so here goes:

The land was here first, so you start with land that has a basic *middleness* about it, then figure in the resources that land has to offer. Next, you start fetching in the people, all the diverse kinds of people who ended up in that middle sort of land, from the very earliest to the moderns, and if your diversity is wide enough—as in a Nielsen Rating—you come up with a fair sampling. You mix up and blend all the culture and experience and character traits of all those diverse peoples, figure in the direct effervescent effects of the mixing itself, which of course changes those people into something they had not been before. You end up with your basic typical Hoosier in Indiana—and there's no two of 'em alike. For example, Cole Porter is not like Red Skelton, and James Dean is not like Gus Grissom, and Dave Letterman is not like James Whitcomb Riley—but they are all Hoosiers, no one more typical than another.

That is about how a Hoosier would sum it up, and there is as much truth as nonsense in it—which is a pretty good average in itself—so let us look at details, beginning with that middle land.

A great, mute truth is that occurrences millions of years ago began forming the resources of what became Indiana and thus contributed to what Hoosiers do and how they are. The formation of limestone and sandstone in ancient sea bottoms and shores; then the compaction of organic matter of the Carboniferous Age into coal and the formation of natural gas pockets; then the sliding, grinding, and depositing effects of mile-thick glaciers—all created the resources by which Hoosiers, aeons later, would make their livings. Quarry stone, coal, gas, forests, rich soil, and rivers were the foundations of Indiana's eventual wealth and employment.

The earliest inhabitants—pre-Hoosiers, we could call them—had no use for the building-stone or the coal, but the deep, lime-rich soil supported the forests and food plants and the profuse game upon which they thrived, and they lived and traveled by rivers.

No one knows just when the Paleo-Indian people first migrated to this glaciated land; estimates of twelve thousand years ago are revised backward as more evidence is found. The region must have been a cornucopia with its woods, fields, streams, and marshes teeming with game animals and birds, turtles, fish, and mussels; with abundant forage foods from nuts and fruits to berries and roots; boundless hardwoods for fuels and building; shell, antler, bone, and flint for

making tools and ornaments; and food prey ranging in size from insects and small fowl to huge woods bison and even mammoth and mastodon. With the glaciers' retreat, a temperate climate settled in, and growing seasons lengthened.

It is fatuous to presume that the original human beings here were brutish, stupid, gibbering ape-men without laws or aspirations or divine beliefs. In truth, the knowledge, courage, judgment, and dexterity required to keep families alive and evolving in a wilderness were at least as impressive as those we exhibit in a mechanized, moneyed civilization. The brain size of those people was no less than ours, their physical strength and endurance were surely much superior, and around their campfires for hundreds of generations they developed their lore and their values and their spirituality. Even when they lived in caves and rock overhangs, brush huts and skin tents, they knew how to cherish and protect their children, work together, laugh for joy and humor, and grieve for pain and death.

It is a pleasant exercise of the imagination to envision a riverside village of, say, the Middle Woodland Period: houses of wattle and clay with thatched roofs, arranged around a plaza with a temple mound, all protected by a high wall; women and children singing as they hoe in fields of corn, squash, beans, and sunflowers; men joking and telling tall tales while making implements and missile points of stone and antler and bone; fishermen and boys wading or diving in the river to set fish traps or standing in hollow-log canoes with fishnets and gigs; hunters coming in from the woods with deer or turkeys over their shoulders, or from the marshes with their boat-bilges full of cattail roots, duck eggs, geese for roasting—all this in the glow and shade of a benign sunny day, the fragrant smoke of cook fires striped with slanting sun beams. In just the same way, we fondly recall our own sunny Labor Day picnics or camp outs in the Hoosierland we know.

It is good to keep such an enlightened image of the aboriginal forebears in mind, in order to rid ourselves of the dark notion that inhabitants of the place we call Indiana were ever a fully hostile, savage people. It is better to imagine that ever since there have been people here, they have been laughing, singing, cooperating, and competing—the way modern Hoosiers do. Just as the basketball fan in his crimson sweater beams with admiration or howls with consternation at the behavior of I.U. coach Bobby Knight, some Woodland native fan cheered or jeered some earlier contest of speed or skill or strength, and laughed and danced when his favorite won.

And who can say there was not some rubbery-faced Stone Age cut-up in some Wabash Valley wigwam who evoked as much laughter in his smaller village audience as Red Skelton or David Letterman? Why not suppose that Hoosiers always enjoyed a good chuckle and a tall tale, even thousands of years before they were called Hoosiers? Even before they were called Indians?

Flint points, pottery shards, and cave-wall graffiti are prehistory, recorded on a small scale. Much more apparent evidence of ancient life is the remarkable array of the great earthen mounds found throughout the Mississippi watershed, with many outstanding examples in Indiana. These ought to dispel the notion that there was no civilization in Indiana before the pioneers came. Some were temple eminences; some, fortifications; some, burial places. Still another kind of mound recording the ancient history of Indiana is the shell midden. Heaps of fresh-water mussel shells, some twenty feet high and extensive enough to support villages, show where mussel-eaters of the Archaic and Early Woodland cultures camped along the rivers century after century, to eat these oyster-like bivalves, extract their pearls, and cut their lustrous shells to make ornaments.

Some ancient mounds, such as the great twelve-hundred-foot circular earthwork at Mounds State Park in Anderson, appear to have been celestial observatories. Others were so immense and well engineered that it was long presumed that some lost white civilization, perhaps refugees from sunken Atlantis, must have built them. A delusion of the Caucasian race is that only Caucasians can do big things well.

Whatever populations built the mounds, they had dispersed by the time of European intrusion into North America, leaving the silent mysteries of their decimation for archaeologists to ponder to this day. The Algonquian tribes living in the region in the eighteenth century explained simply that their ancestors had been the Mound Builders, but few palefaces were willing to believe that. But gradually, archaeological research has supported the theory that it had been the same aboriginal race all the time. Whether wars, social disintegration, or epidemics, something had changed the natives from a sedentary, mound-raising, priest-dominated, urban-centered culture to the democratic, seminomadic, sylvan hunter-farmer-gatherers whom the Europeans encountered here. Archaeologists divide Mound-Builders into two consecutive cultures: the Adena, or Early Woodland (800 B.C. to A.D. 100); then the Hopewell, who flourished between the

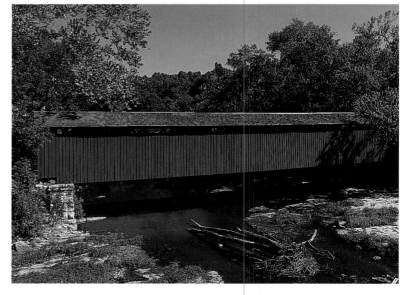

△ *A covered wooden bridge and a spectacular series of waterfalls mark the tiny rustic resort town of Cataract on Mill Creek. It is part of the vast Lieber State Recreation Area, named after the founder of the state's park system, Colonel Richard Lieber.*

Allegheny Mountains and the Great Plains from about 100 B.C. to A.D. 500 or even A.D. 1000.

Of course, those peoples did not call themselves Adenas or Hopewells. The Adenas were named after an estate owned by Ohio pioneer Thomas Worthington, and Hopewell was the name of a settler on whose land a large group of mounds was examined. Most modern Americans, including a certain Terre Haute television newsman, are not even familiar with the terms. That newsman announced, after some old human bones were washed out along a creekbank, "Archaeologists said the bones probably were those of a Hopeful Indian."

If there ever were any "Hopeful Indians," their hopes were in vain after white explorers discovered the incredibly rich heartland of North America. From that moment, the aboriginal way of life was doomed. And Indiana, meaning "the Land of the Indians," became the field for one of the most dramatic chapters in the saga of America's settlement.

There surely is no river in America, not even the Hudson or the Potomac, where more crucial history has been made than the Wabash, Indiana's own fabled river. Except for its source in western Ohio, this beautiful river and most of its tributaries course through Indiana soil, draining almost the entire state. It is a placid, 475-mile-long, arcing river course appearing idyllically peaceful. But along its fertile banks have marched armies—Redcoats and Bluecoats, militias in homespun hunting shirts and leather leggings—fighting for control of this heartland, and warriors of perhaps two dozen tribes sped along its shores year after year to resist white intruders.

The most successful and consequential single campaign of the Revolutionary War—and surely the most incredible—culminated on the banks of the Wabash. In February 1779, a daring twenty-six-year-old Virginian militia colonel named George Rogers Clark led a ragged, starving, half-frozen band of 125 frontier sharp-shooters on a two-hundred-mile midwinter march over sodden prairies and through frozen

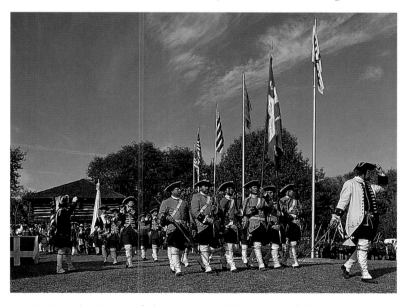

△ During the Feast of the Hunter's Moon at old Fort Ouiatanon, troops in colonial uniforms evoke the ambitions of European kings, who sent their armies to struggle against Indians, rebel Americans, and each other for control of the Wabash watershed.

floodwaters—a march that exceeded all the perceived limits of what soldiers could endure. Then the band surrounded Vincennes and captured the Redcoat governor-general and Fort Sackville, wresting control of the whole vast Northwest Territory (now Ohio, Indiana, Illinois, Michigan, and part of Wisconsin) from the British. The lands thus controlled by Clark became the only asset the bankrupt new nation could cash in on after the Revolution.

In 1790, warriors led by Mishiconogkwa, the Miami war chief known as Little Turtle, whipped the army of General Josiah Harmar after it had attacked and burned his villages at Kekionga, where Fort Wayne now stands.

To punish the Indians, President George Washington sent General Arthur St. Clair into their territory the next year with an army of fourteen hundred. Little Turtle surprised that army on the Wabash headwaters on November 4, 1791, and inflicted on it the worst defeat ever suffered by the Army of the United States, killing more than 650 soldiers and officers, wounding 271, and putting the few survivors to flight. It was not until 1794 that the army, under General "Mad Anthony" Wayne, defeated the confederated tribes and forced Little Turtle to the treaty table. Little Turtle did not call himself a Hoosier, but he was one of the greatest of them.

In the first decade of the nineteenth century, a series of treaties consummated by William Henry Harrison, governor of the Indiana Territory, took thousands of square miles of the Indians' lands; those treaties were held at both ends of the Wabash, at Fort Wayne and Vincennes.

Just before the War of 1812, the cunning Harrison illegally marched an army of one thousand up the Wabash into what was left of the Indian country and destroyed a multitribal religious community founded by the evangelical Shawnee Prophet, Tenskwatawa, and his brother Tecumseh. In fulfilling a vow to avenge that aggression and protect his people's remaining lands, Tecumseh confounded almost all efforts of the U.S. Army in the Great Lakes area until he was killed in Canada in 1813. Much combat of that war, the burning of Indian towns and crops by Harrison's troops, and the tribes' retaliations, occurred along the Wabash at places such as Fort Wayne, the Mississinewa, Tippecanoe, and Terre Haute. Scores of books have been written about the battles, skirmishes, confrontations, captures, marches, and tragedies that occurred all along this river during the Revolution and the Indian Wars. Yet, the image most Americans hold of the Wabash is that described in the Indiana State song penned by Paul Dresser, brother of the great American novelist Theodore Dreiser. Dresser's homesick lyrics:

O the moonlight's fair tonight along the Wabash,
From the fields there comes a breath of new-mown hay.
Through the sycamores the candlelights are gleaming,
On the banks of the Wabash, far away.

Much wonderful nonsense has been told about what a Hoosier is and how he got that name. As is usually the case

with folklore, some truth may lurk somewhere within all the nonsense. Some of the most enduring origins of "Hoosier" are these:

That it comes from an English slang term, *hoozer,* meaning anything large of its kind.

That when anyone knocked at the door of a windowless Indiana pioneer cabin, the inhabitant would call from within, "Who's here?"

That an early Indiana timberman named John Hoosier branded his logs with his name, and when they were seen floating in the Ohio River, they were known to be from Indiana—thus anything from Indiana came to be called by that name.

That during a tavern brawl among knife-wielding Indiana rivermen, someone picked up a severed hearing organ from the floor and inquired, "Whose ear?"

It is as much fun characterizing a Hoosier as a Texan. Both involve a certain sly, drawling boastfulness, and both tend to divert the gullible listener from the truth, if there is any particular truth to begin with. If there is any similarity between two such famous Hoosiers as John Dillinger and Michael Jackson, it is not any more evident than that between Lyndon Johnson and Michael Huffington of Texas. Still, we *need* a stereotypical Hoosier, just as we need a stereotypical Texan, and maybe the best way to depict one of each for comparison is to tell a story about a meeting of the two:

Into the Hoosier hills rode a physically and vocally oversized Texan, who reined in his Cadillac and dismounted to greet a lanky old Hoosier he saw leaning on a rural mailbox. "Howdy, Pappy!" the Texan boomed, pumping his hand. "This heah yoah farm?"

"Yup."

"Lived heah all your life?"

"Not yit," said the Hoosier.

"How big's yoah farm, Pappy?" This being the classic Texan preamble to a comparison.

The Hoosier gestured around with his thumb. "'Long this bobwire fence to that sycamore, down into the gully and back up to that leanin' barn, then back north to the road where that Chevvy sits on them concrete blocks."

"*That's* yoah farm?" bellowed the Texan. "Pappy, let me tell you 'bout *mah* farm! Why, I can get in my car at sunup, an' start drivin' straight in one direction, and by sundown, ah *still* ain't got to th' other side o' *mah* farm!"

The Hoosier nodded. "Yup. I know just what y' mean. That 'air dang ol' Chevvy was jest like that."

On a map, Indiana has a shape something like a wide Christmas stocking one-third full of hickory nuts, the northern and the eastern and upper western borders being straight survey lines, while the southern and southwestern borders— the sole and foot of the "stocking"—are undulating and lumpy because they follow the Ohio and Wabash Rivers, which converge at the "toe." An indentation at the geographic northwest corner is the lower end of Lake Michigan. If not for that

little nip of a Great Lakes shoreline, Indiana's only access to maritime shipping would be its Ohio River ports.

Seen from an airplane, most of Indiana is a gridwork of north-south and east-west roads and tree-lines making perfect one-mile squares, each square being a 640-acre section of a thirty-six-square-mile township. All this precise squaring-up, characteristic of lands west of the Alleghenies, resulted from the master plan called the Northwest Ordinance of 1787, which was intended to impose perfect order upon an untamed landscape.

Because we measure our real estate in acres, Hoosier landowners deal with an ambiguity: if you buy an acre in flatland northern Indiana, you get an acre of land, but in hilly south-central Indiana, the slopes are so steep that you might get nearly two acres of land surface for an acre on the map.

But the flatland acre is so much better to farm that it sort of evens out.

Tongue in cheek, here is Indiana pioneer history, short writ: You claimed land in the territory. You raised troops and tormented the natives until they got fed up and killed you. That would ensure that a county would be named after you.

That is not entirely facetious, for ten of Indiana's counties were named after men involved in just one Indian battle— Tippecanoe. Many others were named after other Indian-fighters and Revolutionary or War of 1812 officers, many of whom were also Indian-killers. Of the five early presidents after whom Indiana counties were named, Washington and Jackson had been Indian-fighters. A few Indiana counties were named after Indian chiefs or tribes. Thus the bloody history of the frontier is reflected throughout the state in the names of its counties.

But it has been a long time since Hoosiers—either students or adults—gave much serious thought to who those namesakes were, or to the blood that has historically soaked their ground.

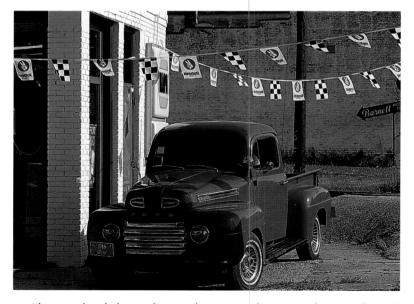

△ *The week of the Indianapolis 500-Mile Race, the motif is all checkered flags and shiny motor vehicles. This rejuvenated pickup truck takes the spring sunshine just before Memorial Day in the little town of Cloverdale, alongside an auto supply store, of course.*

Not much blood soaked the soil of Indiana when the Civil War broke out; only skirmishes and standoffs against John Hunt Morgan's raiders took place within the state's borders. But an inordinate quantity of Hoosier blood was shed on battlefields elsewhere. Indiana's super-patriot Governor Oliver P. Morton pushed his state to raise more troops and financial support per capita than any other Northern state but Maine. Morton turned the State Fairgrounds at Indianapolis into a huge training camp in 1861, converting it the next year into a prisoner-of-war camp holding five thousand Confederate prisoners. An Indiana regiment, the Nineteenth Indiana Volunteers, was part of the toughest brigade in the Union Army, the so-called Iron Brigade. In engagements including Bull Run, Antietam, and Gettysburg, the Iron Brigade suffered the highest percentage of casualties of any Union brigade: on the first day of Gettysburg, it lost two-thirds of its soldiers helping to stop the Confederate assault on McPherson Ridge.

At the very center of the capital city in the center of the state of Indiana stands an ornate carved limestone monument to Indiana's soldiers and sailors, and for half a century no other building in Indianapolis was allowed to be built taller than the monument.

Hoosiers' staunch performance in the Union cause is especially remarkable, considering that half the state had approached the war with a complex of basically Southern sentiments. In 1851, Indiana had passed a law prohibiting immigration of any black persons, including free ones. The older, southern, part of the state was hostile to the banks, industries, railroads, Presbyterians, and other "Yankee" influences that had been a-building north of the National Road. Southern Indiana's economy was based on corn, pigs, timber, whiskey, sweet potatoes, and Ohio River traffic. It was a rural, largely Baptist region, called "sister of Kentucky and daughter of Virginia." It was also characterized as "Butternut," a reference to homespun garb dyed yellow-brown with oil extracted from walnut and hickory trees and famed as the color of

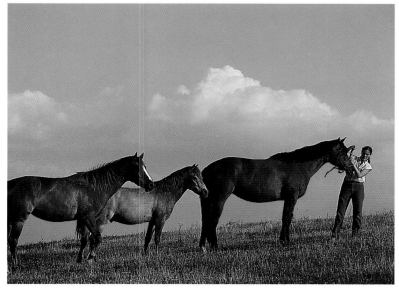

△ *Hoosiers are like Kentuckians in their love and knowledge of horses and horsemanship. From quarterhorse and Western riding events to dressage, jumping, harness racing, and fox hunting, horses earn their oats all over Indiana; some even still pull plows.*

the Confederate uniforms. Many Indiana Butternuts fled from or resisted conscription into the Union Army. Two enlistment officers were murdered by mobs in Indiana Butternut districts.

But so diverse was the Hoosier character even then that many southern Indiana citizens—especially Quakers—assumed the great risks of smuggling fugitive slaves northward along the secret Underground Railroad. And when it came to the principle of preserving the Union, that became a stronger motive for many soldier-age Hoosiers than their old anti-Yankee, pro-South sentiments formerly had been. When Indiana's border-state neighbor to the south, Kentucky, quit a brief attempt at neutrality and went Union, rebel tendencies in southern Indiana faded.

But even far into the war, there were organized Rebel sympathizers in Indiana, known as the Sons of Liberty or the Knights of the Golden Circle—precursors of the Ku Klux Klan. In 1864, a conspiracy to overthrow the government and release Confederate prisoners was nipped in the bud, and the plotters were brought to trial in Indianapolis for treason.

Sixty years later, Indiana had the nation's largest Ku Klux Klan membership; even today you can see the Butternut attitude, in Confederate flag license plates displayed on cars and pickup trucks in the Indiana hills. Some attitudes never die.

Still, in wars since that one between the states, many of the best soldiers fighting alongside black comrades have been those same tough Hoosier boys who like to flaunt the Stars and Bars.

Most Hoosiers, like most anybody, are anonymous, and the public elsewhere cannot tell much about what a Hoosier is like from that main population.

But there are certain vocations that lift their practitioners into public view, and it is from these that the public at large gets its impressions of what a Hoosier is like.

Those high-profile vocations are politics and crime (which because of certain subtle distinctions can be called separate vocations), show business (which resembles, but is technically not politics), literature (which often overlaps show business), and sports (which is a peculiar branch of show business in which the stars wear numbers on their costumes and do not sing).

Many books have recorded the lives of Hoosiers prominent in those respective vocations. Here we have room only to scan some of the more famous and notorious and leave the reader to draw his own conclusion—being perhaps that anonymity is a good and merciful thing, more to be desired than it generally seems.

Frontier Indiana created the first truly modern presidential candidate—meaning one whose image and persona were deliberately reshaped to satisfy the perceived tastes of the voters. This was William Henry Harrison, already mentioned as the soldier-governor who relieved the Indians of their lands and pursued Tecumseh to his death. Harrison, born into the Virginia Tidewater aristocracy and full of classical education, campaigned on the Whig ticket in 1839 as the "log cabin

and hard cider" candidate with John Tyler as his running mate. Using such innovations as campaign songs and party insignia, and wearing a homespun aura embellished by tall tales, he won over incumbent Martin Van Buren by 234 electoral votes to 60. Standing in a chill wind to give the longest inaugural speech ever, he came down with pneumonia and, after a month in the White House, became the first U.S. President to die in office. His grandson, Benjamin Harrison, born near Cincinnati but a Hoosier from the age of twenty-one, became the twenty-third president after service in the Union Army and Congress. Having no need to feign rusticity in 1888, he was an out-and-out autocrat.

Indiana's genuine log-cabin president was Abraham Lincoln, who, though born in Kentucky, grew up and developed his principles, rugged strength, and intelligence in Spencer County, Indiana, from his seventh to his twenty-first year. It was here that he split rails and voraciously studied borrowed books by firelight, those two enduring images of the true log-cabin president. A state park and a national memorial in Spencer County commemorate his neighborhood.

Indiana almost placed another president in the White House in 1940, when Republican candidate Wendell Willkie of Elwood ran against incumbent Franklin D. Roosevelt. Though Willkie was a high-powered corporate lawyer and president of a big utility holding company, the national press mocked him as a Hoosier hick from a "two-event" Hoosier town—the two events being the Tomato Festival and Willkie's nomination. Perhaps the press had forgotten how shrewdly a "Hoosier hick" could run the country, as Abe Lincoln had proven. Hoosier hick Willkie startled the nation by garnering an astonishing 45 percent of the popular vote—twenty-two million—in his run against the great FDR.

Not all famous Hoosier politicians have been characterized as hicks, though. Senator Homer E. Capehart, it was said, was a cartoonist's dream, that the longtime Republican lawmaker and FDR critic made caricature unnecessary because his Senator Phogbound looks and actions were made to order. He was an example of the overlap of politics and entertainment: a radio and phonograph tycoon who patented the record-changing device for Wurlitzer Company, facilitating the advent of the jukebox, in 1934. Being part of the entertainment scene, the portly senator was as aware of his image as his mockers were. That was perhaps his most Hoosierly trait: the ability to stand off to the side with a wry half-smile, enjoying the world's concept of him.

One of the more recent famous Indiana politicians suffered ridicule of a different sort from the press—not because he looked anything like a hick. The well-groomed, model-handsome scion of a powerful conservative Indiana publishing family, P. Danforth Quayle was serving in the Senate when he was picked to be George Bush's vice-president. In his zeal to defend American family values, Quayle attacked a popular television situation comedy heroine as an example of moral decay. For demonizing a fictional character as if she were real, Quayle endured a storm of media mockery.

It has been said that the best politicians come from small towns because they understand politics from the roots up. In Indiana, a state that pretends even its big cities are towns, politics lie close under the skin. There is a saying that when a Hoosier baby starts to talk, his first words are, "Although I am not a candidate for any public office, if nominated . . ."

Indiana's most famous criminal, bank robber John Dillinger of the Depression era, enjoyed comparison with Robin Hood—although few of the people whose money he stole were "the rich," and "the poor" he gave to were mostly his own folks and henchmen and girlfriends. At any rate, his crime wave, his escapes, his pursuit by "G-Men" who finally shot him to death as he emerged from an Chicago movie house, were a tonic for Depression-weary Hoosiers who were vicariously tickled to see someone take the money and run. Though his hometown was Mooresville, just south of Indianapolis, most Dillinger lore has been concentrated since 1976 in the John Dillinger Historical Museum in rustic Nashville, a tourist Mecca—where more people are likely to see it. Few Mooresville folks boast any more about their homegrown gangster. After all, if you live in the nation's moral center, you do not really believe in lawlessness.

That spectacular crime, the train robbery, is associated in most minds with Western gunmen, but it was invented in Indiana in 1866 by the infamous Reno brothers when they pulled off the first train holdup on the outskirts of Seymour.

A Hoosier bandit who did rob trains in the West was Sam Bass, born on a Lawrence County farm in 1851. He was one of the West's best-known desperadoes of his time, robbing banks and stagecoaches before being killed at age twenty-seven.

The state's foremost serial killer was a woman—big, wide Belle Gunness of LaPorte, who lured at least fourteen men into marriage, killed them for the insurance money, and disposed of their bodies on her farm. Much of her *modus operandi* is speculative, because the gents' remains were not

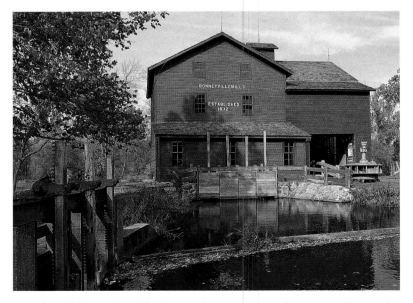

△ *The oldest gristmill in continuous operation in Indiana, the Bonneyville Mill was built on the Little Elkhart River in 1832 by miller, adventurer, soldier, and convicted counterfeiter Edward Bonney; it still grinds buckwheat flour for sale to visitors.*

found until Belle's house burned down in 1908—supposedly with her in it, although one theory is that she used the fire to mask her disappearance. Belle was not a typical Hoosier, but she was smart enough to be.

As for show business, any effort to list all the nationally famous entertainers and media celebrities here would fail; even if enough pages were available, some would be omitted by the author's ignorance and oversight. Even an impromptu roll call would show only that famous Hoosier entertainers have been so varied that they give little clue to the elusive Hoosier character.

Maybe the Clem Kadiddlehopper character created by Red Skelton—born Richard Bernard Skelton in Vincennes in 1913—was supposed to exemplify a real Hoosier hick, but we Hoosiers hope not. Some Hoosier drollery that really rang true was that of early television humorist Herb Shriner, born elsewhere but brought to Fort Wayne as a baby; he used to say, "I wasn't born in Indianny, but I came over as soon as I heard about it."

But what is noticeably Hoosier-like about actresses Shelly Long and Carole Lombard, both born in Fort Wayne; or Florence Henderson of Rockport; or Phil Harris the famous Linton native; or actor James Dean of Fairmount; or David Letterman of Indianapolis, reigning late-night television goof; or John Cougar Mellencamp, rock musician from Seymour? Does Michael Jackson of Gary strike anyone as a typical Hoosier? Well, probably not, although his "moon walk" might look familiar to anyone who has just come in from the cow pasture.

One might have to be a fan of really old movies to remember Hoosier Elmo Lincoln, who played the first Tarzan on-screen; or Irene Dunne of Madison; or actor Richard Bennett and his daughters Joan Bennett and Constance Bennett, all sophisticated stars whose ancestral home was Bennett's Switch in Miami County.

△ *Not all Hoosier farming is state-of-the-art high-tech agribusiness like that developed at Purdue University's great agriculture school; down in the hills, marginal farmers still get in the hay with whatever equipment they can keep running.*

Most Hoosiers are full of songs they have just failed to get around to writing or recording yet. Just ask 'em. But the state's most famous songwriters were Paul Dresser, a Terre Haute native who made it big on Tin Pan Alley around the turn of the century; Hoagy Carmichael, who wrote the best-known of all popular songs, "Stardust," while he was a law student at Indiana University in 1927; and Cole Porter of Peru, the author of worldly lyrics and such unforgettable numbers as "In the Still of the Night" and "Begin the Beguine," and "Anything Goes."

Dresser became more Big Apple than Hoosier, though his "On the Banks of the Wabash" became the Indiana state song. Porter hardly seemed Hoosier at all, coming from one of America's wealthiest families, educated at both Harvard and Yale, and a cosmopolite who chummed with the likes of Noel Coward. So the most Hoosier-like of the Big Three seems to be Carmichael—easy-going, raffish, singing his "Old Buttermilk Sky" with a Hoosier twang. That, to a Hoosier, is heartwarmingly Hoosier-like.

But who remembers that the composer of the ubiquitous tune "Take Me Out to the Ball Game" was a Hoosier, Albert Von Tilzer; or that his brother, Harry, was the state's most prolific songwriter and coiner of the term, "Tin Pan Alley"? Harry's output of some eight thousand songs included "Wait Till the Sun Shines, Nellie" and "I Want a Girl Just Like the Girl that Married Dear Old Dad."

American entertainment has a definite star system, which divides performers into two groups: the top stars, and all those others who are just as talented as the famous ones but who have missed out on the luck to become as well known. Most Hoosiers will readily admit that they are in the latter category. In Indiana, the making of live music never lets up—classical, popular, jazz, and country—and rare is the city without an orchestra or ensemble. Indianapolis has always had an active, first-rate jazz scene, much of it along old Indiana Avenue, once known as "Black Broadway," where everyone who was ever big in jazz and blues—Eubie Blake, Cab Calloway, Ella Fitzgerald, Ethel Waters, Jimmy Lundsford—performed. Throughout living memory, the Indianapolis Symphony has been among the most respected in the country.

Indiana University's School of Music at Bloomington, one of the country's best, both draws and radiates talent: producing instrumentalists, singers, and dancers while attracting masters from all over the world to teach and to perform for audiences grown accustomed to the best. As for jazz at I.U., renowned composer and innovator Dave Baker heads the school's jazz department.

It would be hard to find anywhere a town of Bloomington's size that offers so many live rock, jazz, and vocal groups in its numerous downtown clubs and watering-holes. The vicinity of Bloomington and nearby Nashville is equally alive with folk and country music. The Little Nashville Opry, whose patron spirit is Bill Monroe, attracts most of the same folks who star in Big Nashville's milieu.

A phenomenon to ponder on is the Hoosier state's disproportionate number of famous and bestselling writers.

A study of the first half of the twentieth century's bestselling books revealed that books by Hoosier authors sold better than those of every other state except New York (which had four times the population of Indiana). Arriving at a point score calculated on numbers of books and their placement on bestseller lists, New York had a score of 218; Indiana was a close second with a score of 213. Third-place Pennsylvania was only 125, and the scale went on down to California's tenth place with a score of 64. That score astonished (and probably insulted) a lot of Easterners, but Hoosiers just shrugged and nodded, and now and then ventured explanations. It is Indiana's climate, said Victor Powell, once dean of Wabash College—too hot and humid in summer, and too damp, chilly and slushy in winter—so, "the Hoosier stays indoors and dreams and what could be more conducive to writing?"

Hoosier humorist Kin Hubbard attributed it, if not to climate, to "something in the air," so transcontinental tourists no sooner cross the state line into Indiana than "plots fer novels an' rhymes fer verses come o'er 'em so fast an' thick that they kin hardly see the road, an' often go in the ditch."

Not accepting such specious homespun explanations, countless scholars have done earnest theses and dissertations analyzing Indiana's literary prominence. Why should writers from a place like Indiana turn out so much readable stuff in every field of fiction, poetry, nonfiction, plays, essays, history, and every scholastic discipline, winning literature prizes? Why so many bestsellers? Readers know of Kurt Vonnegut Jr. and Theodore Dreiser and Dan Wakefield, and may remember Edward Eggleston and Booth Tarkington, Meredith Nicholson, Charles Major, George Barr McCutcheon, and Maurice Thompson and Jessamyn West. Some might quibble whether Jim Davis of Muncie, creator of *Garfield,* is technically an author, but if he had been included in that earlier survey, Indiana surely would have been ahead of even New York, because, in the early 1980s, Davis had seven books on the bestseller list at the same time.

Bestsellers are not always critically acclaimed books, of course. James Whitcomb Riley's colloquial verses, General Lew Wallace's epic *Ben Hur,* and Gene Stratton Porter's popular youth stories have not been esteemed as literary art. Some Easterners would have it that Hoosier writers have been bestsellers because they are (sniff) *popular.*

Other explanations for Hoosier literary output are interesting, and some show insight. Indiana became a state in the formative years of the public school system, when more people were becoming literate. The state was settled by Virginians and Kentuckians, Scotch-Irish, and Germans—loquacious, droll, bardic sorts of people with big tales to tell (pioneers, Revolutionary War, War of 1812, and Mexican War veterans). All had come to a new country where any man was free to say whatever he thought needed saying. The Eastern literary influence—Emerson, Thoreau, Melville, Longfellow, Cooper, Washington Irving—no doubt reached Indiana at a propitious

time to stir the latent poets and storytellers, and inspire them both by example and the exhilaration of strong ideas. School teachers and prominent citizens encouraged literary endeavors by establishing hundreds of reading circles and literary clubs; Indianapolis alone had forty such clubs at one time. If there was a time for writers to become "stars," that was it, and it blossomed into a Golden Age for authors.

General Lew Wallace was perhaps Indiana's first literary "star" and is important to consider because he was an example of the transition from "gentlemen who happen to write" to those whose main occupation was writing. As a Union Army officer, politically appointed, General Wallace was not a spectacular success—his main claim to fame was taking the wrong road and getting his division lost on the way to the Shiloh battlefield. He wrote a historical romance while serving as an Indiana lawyer after the war, and penned *Ben Hur* while serving as governor of the New Mexico Territory. After its immense popular success, he was considered a writer instead of a public figure who wrote, and returned to Indiana to continue his career.

A clergyman who turned professional author was Edward Eggleston, with his *Hoosier Schoolmaster* gaining fame as a sharp portrayal of backwoods Indiana. Booth Tarkington, born in Indianapolis, won Pulitzer Prizes for *The Magnificent Ambersons* (1918) and *Alice Adams* (1921), but is best remembered by Hoosiers for *Penrod* and *Seventeen,* his humorous accounts of growing up in Indiana. James Whitcomb Riley was a town boy who wrote colloquial verse putting a nostalgic, bucolic haze over everything Hoosier— even poverty—and became the state's poet laureate, favorite writer, and probably its most beloved citizen ever.

For many years, George Ade was what could be called the "most famous American humorous author who was not Twain." His bestselling *Fables in Slang* (1899) brought him fame and riches, and he penned newspaper humor columns, comedies, light opera, and screenplays. In fact, he was one of

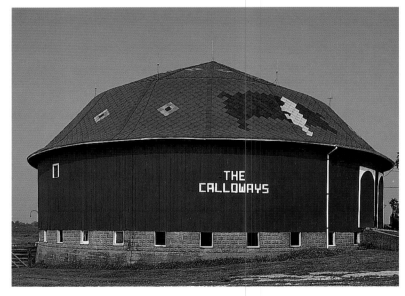

△ *Round barn design was touted at the turn of the century for its cheapness of construction and efficiency of operation. Fulton County boasts one of the highest concentrations of round barns, so it hosts a Round Barn Festival every July.*

the most successful playwrights of his era, once having three plays running simultaneously in New York. He was known for such flippant moral lessons as "Early to bed and early to rise and you'll meet very few prominent people."

These Hoosier authors were not poor struggling garret-scribblers, but a pride of literary lions, living the lifestyle of the wits and the famous—but still able to act the way one expects Hoosiers to act. Ade had a sumptuous two-thousand-acre estate at Brooke, Indiana, where famous writers gathered with tycoons, other celebrities such as Will Rogers, and political figures up to and including Presidents William Howard Taft and Theodore Roosevelt. On one of Ade's visits to the southern Indiana mineral springs resort at French Lick, so the story goes, Ade pulled a prank any Hoosier boy would have envied. The famous "Pluto Water" at the resort was touted as a purgative, and a row of white outhouses stood downslope from the grand hotel, each furnished with a red cane; to signify that an outhouse was in use, its occupant would hang the cane from a peg on the outside of the door. Ade slipped out of the hotel at first light and hung the canes on all the doors, then sat smiling to watch as some of America's richest spa-goers hurried down to the privies for their morning constitutionals—and fidgeted and waited, fidgeted and waited, much too proper to knock and inquire within.

Ross Lockridge Jr. of Bloomington rocketed to national literary fame in 1948 with his giant historical romance, *Raintree County,* subject of a lavish Elizabeth Taylor movie, but he died mysteriously the same year before literary critics could determine whether he was a true genius or a shooting star.

As much as Indiana spawned popular writers, it seldom made the truly serious ones feel at home. Like the rest of the Midwest with its new concern for respectability, Indiana was hostile to psychological insight and social criticism. Except for "regional" or "colloquial" writers, most Hoosier authors yearned to get away to New York, or to any place where the minds of the neighbors were less dour, where Eros could

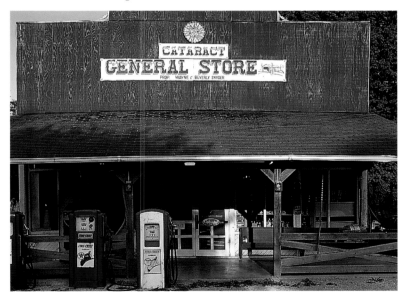

△ *It helps to have a good navigator to find the town of Cataract via poorly marked county roads, but the old country store near the falls is authentically old-timey and worth the trip back through time. The quaint town also has shops and summer cottages.*

mean creativity and self-realization, not just lust, where the heart's impulses were not oppressed by fear of gossip. Scott Sanders, an award-winning storyteller and essayist at Indiana University, may have expressed the Hoosier literary dilemma clearest when he called Midwest culture "the result of imposing a religion that fears the body onto a region that is all body." He asks, ". . . where is the fear of sexuality or suspicion of the flesh more severe than here in this juicy region, where corn thrusts skyward and hogs breed and birds flock and every living thing sprouts and fattens? . . . Nowhere else in America are fertility and prudery so at odds." Much of the serious and good writing about the Midwest was done by writers who had fled its stifling respectability for places where culture was more stimulating—and who then looked back longingly at the fecundity of the land itself and wrote more beautifully and truly about land and the people it produces.

Land does produce its particular people, just as it produces other particular crops, and Hoosiers are the way they are because of this rich middle land of their roots.

The legend of Knute Rockne, famed football coach of Notre Dame's "Four Horsemen of the Apocalypse"—who is associated forever with the famed movie line, "Win one for the Gipper"—proves that as much fiction can be written in sports as in literature.

This is not to deny it was great football. But the Hollywood version of Rockne as a warmhearted saint hardly resembles the practical, greedy, ruthless self-promoter who began turning college sport into the excessive, big-time kind of show business it is today. And George Gipp, whose touching last admonition was uttered through the lips of Ronald Reagan in the film, was actually a truant who played ball and studied only when he took a break from drinking and partying—and who, by the way, never said "Win one for the Gipper."

What Rockne did in Indiana for sports was essentially what ambitious Hoosier entrepreneurs in other fields have done—from Anton Hulman in auto racing to Colonel Harlan Sanders in fried chicken. Meanwhile, Rockne paved the way for such legendary coaching phenomena as Bobby Knight.

Hoosiers probably are no more sports-crazy than the rest of the American population, but it can seem so to anyone who lives in Indiana and is surrounded by the frenzy. There is a parallel here between sports and literature: little Indiana seems to have had a disproportionate number of great athletes and spectacular sporting events. Some snide folks say Hoosiers are so sports-obsessed because there is nothing else exciting in Hoosier daily life.

More than two hundred native Hoosiers—including Carl Erskine, Don Larsen, Gil Hodges, and Chuck Klein—have played major league baseball in the years since 1884. An Indiana University athlete (swimmer Mark Spitz) won the record number of gold medals in a single Olympics (seven, in 1972). Raymond Ewry of Purdue won more total Olympic golds than any other athlete (ten in track and field jumping events between 1900 and 1908). Football and golf and

hockey and boxing are full-fledged sports in Indiana. But despite all this, the two intrinsic Hoosier sports are basketball and auto racing.

A Hoosier definition of an abused child would be a boy whose father would not install a basketball hoop on the front of the garage. At all hours in all weathers, you hear the pneumatic *thunk, thunk, thunk* of dribbling on neighborhood drive-ways and the shuddery impact of a far-flung ball banking off the backboard. As they practice tirelessly, those driveway athletes may be envisioning themselves as Larry Bird, the so-called "hick from French Lick" who went from high school basketball to a dazzling professional career with the Boston Celtics. Or maybe they imagine themselves in the last screaming seconds of an NCAA tournament with seven-foot-tall opponents leaping all around them and Bobby Knight's glowering eyes and volcanic mouth increasing the adrenal flow.

Of all the memorable moments in Indiana basketball history, the one that assumes the shape of legend was the 1954 night when the basketball team of tiny Milan High School—student body a mere 161 boys and girls—fought its way to the state high school basketball crown. That year, Milan was celebrating its centennial when the plucky team gave it something else to celebrate. That game was re-created in the 1986 movie, *Hoosiers,* with Dennis Hopper and Gene Hackman. But in the film, the town was called Hickory, Indiana. The screenplay was by Anthony Pizzo, a Bloomington native who knows that in all the hyped-up world of professional basketball, there is nothing comparable to the excitement of a town whose own kids are winning the game.

Of all human events, only war comes to mind as something imaginably larger, louder, and more famous than the Indianapolis 500-Mile Race at Speedway—and not many wars are that famous, or preceded by so many pageants and parades. In the month of May in Indianapolis, it is not a good idea to plan any social event, or even a drive across town, without first consulting the 500 Festival schedule. The city's life is as caught up in it as New Orleans is in its Mardi Gras. There is scarcely anything advertised without a picture of a checkered flag to tie it in with the "500." The city's boosterism is to the point of giddiness. Then, after a month of that, comes the race itself.

What could be more famously familiar than the incredible traffic jams, the hundreds of thousands of excited human beings within a square mile, the release of thousands of bright-colored balloons, the National Anthem sung over a loudspeaker, and then those words of command which, through some grave oversight, have been omitted from *Bartlett's Familiar Quotations:*

"GENTLEMEN, START YOUR ENGINES!"

Immediately follows a din like nothing else on earth: thirty-three powerful racing engines all firing up and revving at once, comparable to the sound of chain saws cutting up bathtubs, while a quarter of a million spectators yell and applaud.

Automobile racing's immense appeal could be explained by the fact that nearly everybody has known the thrill of driving a bit too fast and can identify with the competitors. And it seems appropriate that auto racing's premier spectacle is in Indiana, because the state was the true cradle of automobile manufacturing.

Automobile making rose to prominence in Indiana just as capitalism and industry were rising to challenge the state's agricultural character. Not surprisingly, many of the auto industries had their beginnings in the nineteenth century with the manufacture of buggies and carriages. One harbinger was a wonderfully succinct contract drawn up by two brothers named Studebaker:

> *I, Henry Studebaker, agree to sell all the wagons my brother Clem can make.*
> HENRY STUDEBAKER

> *I agree to make all he can sell.*
> CLEM STUDEBAKER

The brothers grew prosperous supplying wagons to the Union Army in the Civil War. It follows that when horseless carriages became feasible three decades later, wagon-makers like the Studebakers would start making them. But first it was necessary for an inventive Hoosier named Elwood Haynes to develop a rubber-tired, gasoline-powered, spark-ignited automobile, having decided against steam or electricity as its power source. At Kokomo on the Fourth of July 1894, Haynes started up his 820-pound contraption and drove it around the countryside at almost seven miles an hour, and pronounced himself satisfied. The American automobile was on its way to becoming one of Indiana's leading products, as well as the machine that would change the shape of the nation's cities, infrastructure, and social behavior for the next century—not to mention creating the greatest sports spectacle in the world.

At various times, forty-four different makes of automobiles were manufactured in Indianapolis, far more than in any

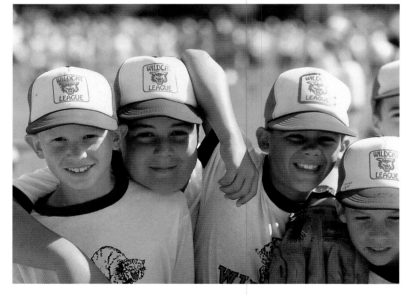

△ Motto: "Anybody can play!" The Wildcat Baseball League at Fort Wayne will not reject any kid who wants to compete. The program was started in 1961 by the Dale W. McMillan Foundation; soybean processing pioneer McMillan was head of food giant Central Soya.

other city anywhere—and that was a mere fraction of the variety produced in the whole state; 208 automobile manufacturers rose and fell in Indiana before Detroit began to dominate the industry in the 1920s. Many were utterly forgotten, while other long-gone Hoosier makes, such as the Stutz and the Duesenberg, are legends of power and elegance.

Indiana's boom in automotive manufacturing overlapped its literary heyday, and is just as intriguing to explain. The state at that time was aswarm with new breeds of capital investors, promoters, inventors, tinkerers, dreamers, sportsmen—and combinations thereof. Electricity, telephones, and indoor plumbing were new, and had created an exciting attitude that anything could be engineered—and profitably at that. That sense of limitless possibility prevailed in most of the nation, but in Indiana and much of the Midwest it was enhanced by very real advantages: coal, natural gas, and other raw resources; a growing population for cheap labor; a network of railroads; a burgeoning steel industry at the foot of Lake Michigan; and an unabashed devotion to the idea that business and material progress were glorious. Here was proud proof that Indiana could produce something besides corn and hogs.

Flamboyant Carl Fisher, born in Greensburg, was the archetypal auto-age promoter. Making his fortune with automobile lights and real estate, he founded and built, with three other businessmen, the Indianapolis Motor Speedway with its famous brick oval track. He lived the life of a free-spending sportsman. Eventually, he developed Miami Beach, prompting Will Rogers to call him "the man that took Miami Beach away from the alligators and gave it to the Indianians." Who knows why Rogers did not say "Hoosiers"—a term you would think a Sooner like Rogers would use any time he could.

Automobiles were by no means Indiana's only big manufacture. The state was, in fact, the nation's leading maker of glass products, with more than a hundred glass factories; of raw steel, copper rods and bars, wire and roller bearings;

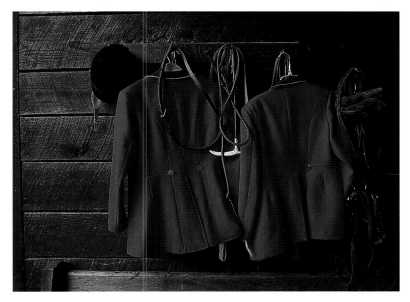

△ *English riding dress and tack hang in a stable near Patricksburg, a backwoodsy area where you would expect equestrian sport to consist of coon hunting on muleback (which actually does exist). There are fox-hunting clubs in many parts of the state.*

many varieties of pumps and electric motors, symphonic and band wind instruments; and even burial caskets. Soon it would become a chief manufacturer of prefabricated housing and mobile homes.

A significant part of this statewide industrial boom was the sudden rise, at Lake Michigan's southern tip, of a kind of city entirely new to Indiana: the grimy city of smokestacks and steel furnaces, black mountains of coal interwoven with shining train tracks, gigantic refineries and foundries, mountains of ore and slag where shortly before there had been only sand dunes and marshes, reeds and marram grass, fish and waterfowl. Here capitalists built a mighty plexus of plants and ports, spreading southeastward from Chicago along the lakeshore, employing tens of thousands of brawny Slav and Pole immigrants, and child laborers as well. Here sprawled overlapping industrial towns ruled by the factory whistle, serenaded by the cacophony of clattering railroad cars, droning foghorns and clanking pile-drivers: Hammond, Gary, Whiting, East Chicago. Like a malignant sore, this thriving mass of activity seeped poison into the land and the lake; but it was seen as a triumph of human endeavor, providing jobs, producing fortunes, aiding industrial growth elsewhere in the state, and buttressing the industrial might through which the United States became a global power and won world wars.

It also created battlegrounds of the brutal conflict between capital and labor.

Two Hoosiers, one on each side, made history in that conflict. The name of David M. Parry, carriage and automobile manufacturer and the influential president of the National Association of Manufacturers, may be remembered only by businessmen; but Eugene V. Debs, Terre Haute–born railroad labor organizer and perennial Socialist Party presidential candidate, remains a legend of controversy, courage, and compassion. His credo still may produce shivers of inspiration or shudders of horror, depending on your stand: "Where there is a lower class I am in it; while there is a criminal element I am of it; where there is a soul in prison I am not free." In fact, Debs was in prison—convicted under the Espionage Act for a speech he had given—when he won nearly a million votes as Socialist presidential candidate in 1920. His U.S. citizenship was taken from him, and because of his anti-war and anti-capitalist convictions, President Harding would not restore it even after he was out of prison. Debs lamented, "I am not a citizen of the United States, despite the fact that I was born and reared in Indiana."

Debs lost faith in the Russian Revolution when he saw its leaders become dictators, but he never let up on the capitalists, who, he insisted, had taken from workers the ability to control their own lives. James Whitcomb Riley, who was a friend of Debs but also of many captains of industry, wrote, "God was feeling mighty good when he made 'Gene Debs, and he didn't have anything else to do all day."

David Parry, at the other end of the spectrum, probably was the most vituperative enemy organized labor ever had, and became famous for both his speeches and his writings:

"It is the business of every man to get all he can . . . it is right and just that one man should obtain more of this world's goods than another. . . . That is what causes progress and the evolution of the race." Parry believed that strikers were law-breakers, that boycotts were "immoral and un-American," and that one who believed in socialism was "a traitor at heart to his country." For his views and activities, Parry was lionized by pro-business President McKinley and invited by Theodore Roosevelt to share the national ticket with him in 1904. Parry declined, as he had declined an offer to debate American Federation of Labor president Sam Gompers at an Indianapolis Labor Day rally the year before.

The battle between labor and capital went through many long, bloody years, with rhetoric and insults, clubbings and shootings, mobs clashing with hired strongmen, as violent and impassioned as the old Indian Wars had been a century earlier. Another world-famous labor leader, Jimmy Hoffa, was born in Brazil, Indiana, in 1913, son of a coal driller. Under his leadership, the International Brotherhood of Teamsters would later grow to be the biggest union in the United States, and then he met a violent and mysterious end.

Indiana is thought of, when it is thought of at all, as a peaceful, pastoral place where the only excitement ever generated was on race tracks and basketball courts. But that image grows out of short memory. Some of the grandest and meanest ideas of American history have been fought out within its borders.

Among the ugly things Indiana history teachers least enjoy teaching is that in the early 1920s, the state boasted almost half a million Ku Klux Klan members, the largest state roll anywhere. The Klan was under the charismatic guidance of Indiana Grand Dragon David C. Stephenson, who boasted, "I am the law in Indiana"—until a murder and morals case proved him worse than even the Klansmen could stomach.

Stephenson grew rich selling KKK memberships and costumes. Capitalizing on vestiges of the old Butternut attitudes, he rallied his membership to wage anonymous fear campaigns against Jews, Catholics, foreigners, and the blacks who migrated toward the labor markets. They also fulminated against such "godless" ideas as evolution and Bolshevism, menacing anyone deemed un-American or immoral. The KKK "knights" fancied themselves protectors of feminine virtue, which gave them an excuse to prowl the Lover's Lanes where the newly mobile young parked their cars at night. Their numbers and their professed righteousness befuddled many politicians, and Stephenson soon owned the souls of many of them, whose secrets he had grubbed up.

But when Stephenson was indicted for the drunken abduction, rape, and possible poisoning death of a pretty secretary from a respected Indianapolis family, his white-robed followers began to desert the "Invisible Empire" by the thousands, and a Pulitzer Prize–winning anti-Klan campaign by the Indianapolis Times in 1928 further thinned the ranks. The Klan upsurge in the state seemed to have been more a matter of

28

Stephenson's salesmanship than the die-hard Hoosier desire to be "sheetheads."

But even now, three-quarters of a century later, vestiges of the Klan remain in Indiana. The amiable farm neighbor who pulls your car out of the ditch with his tractor might, in his spare evenings, have a secret life of vaguely chivalrous, self-righteous notions, and a robe and white satin headdress may be hidden in the back of his closet. A curious tourist once asked, "Is there any connection between these KAMPER KORNER and KOZY KABINS billboards here in Indiana and the old Klans and Kleagles, or is it just a coincidence?"

"A Koincidence," his Hoosier guide corrected him. "Just a Kute way to spell."

As much as any other state, Indiana is firmly plugged in to the world of mass communications and the Information Superhighway—not much more provincial than other places. Still, many Hoosiers cling stubbornly and suspiciously to the old Bible Belt certainties they were raised on. Just a generation ago, Indianapolis boasted a big downtown art and stationery store whose gallery specialized in two kinds of framed paintings: Brown County hillscapes, and pictures of the Savior—radiant, blue-eyed, and auburn-haired. The store's sales allegedly peaked on a year when somebody produced prints of a scene called "Christ in Brown County."

And even more recently, a matronly school board member objected to a motion to require that a foreign language be included in the curriculum of the high school in her southern Indiana town by shouting, "If English was good enough for Jesus Christ, it's good enough for those students!"

Whichever political party is in office, Indiana government has been on the conservative side. The primary newspapers have tended to be conservative, particularly those owned by Indiana's most influential publishing family, the Pulliams. The Indianapolis Star, a morning paper, and the Indianapolis News, afternoon, years ago had to compete with a feisty little

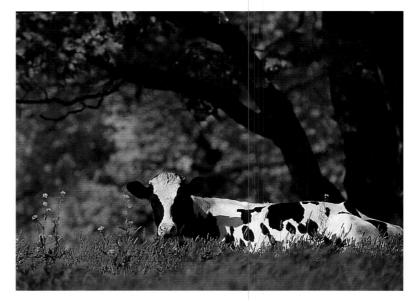

△ The livin' is easy, even if you're a cow in the city. For years, Indianapolis was mocked as "a farm with streetlights." Now both dynamic and progressive, the city still maintains pastoral havens where a bovine can rest and make milk.

Scripps-Howard daily, the Indianapolis *Times,* and they nominally competed with each other after the rival *Times* folded in 1965. Obviously uncomfortable with the advantage of having the only papers in town, publisher Eugene Pulliam Sr. advocated the so-called "Op-Ed page" where opinions opposite to his own could be aired. Still, the Pulliam papers in Indianapolis, Muncie, and Vincennes remained conservative.

The sense of Indianapolis' basically conservative ambience was enhanced in 1984 when the Hudson Institute moved from New York State to a stone mansion in the Hoosier capital—the same year the Colts football team came from Baltimore. These additions to the city continued a revitalization that had begun in the 1960s when Mayor John Barton set up a powerful city progress committee and reversed the city's policy of refusing federal funds. His successor, Richard Lugar, over time a U.S. senator and Republican presidential candidate, pushed a bill authorizing a merger of the city and county governments to eliminate overlapping jurisdictions. Another Republican mayor, Richard Hudnut, then presided over a period in which the city skyline sprouted with skyscrapers and athletic arenas, becoming the "Amateur Sports Capital of the World" and accommodating the Pan American Games and World Gymnastics Championships, among other events. Once called a "farm with streetlights," Indianapolis is now ranked as one of the most successful cities in the nation.

On meeting a Hoosier, most non-Hoosiers mention Coach Bobby Knight, or the "500," or the Colts. Now and then one will say, "Ah! Kinsey! The Sex Institute!"

The Institute for Sex Research made America turn and gape at Indiana. To some, it seems almost funny that anything like it would have been in Indiana, that staid Nowhere. It was and still is controversial.

Indiana University professor Dr. Alfred Kinsey had been a researcher on wasps, and had he remained in his old field, his

△ *Streamlining, power, elegance, and sportiness were some of the contributions made to automobile design by car manufacturers in Auburn, Indiana, before the shutdowns of the Great Depression. Every Labor Day, classic car buffs attend a festival.*

name would have been obscure. But with the results of his massive study on human sexual behavior—mostly by interviewing nameless sources and compiling statistics—he upset America's perception of this secretive aspect of life and threw the nation into a state of titillated shock. Some observers allege that his reports actually precipitated the so-called "sexual revolution." Whatever the enduring controversies about the Institute and its findings, one plain fact about Kinsey himself is that he was a thorough, prolific, concentrated, tireless researcher. A social acquaintance of the Kinsey family once encountered Mrs. Kinsey and inquired about the doctor's health, to which she replied, "Oh, Alfred's fine, I suppose. I haven't seen him much since he took up sex."

Some poets and writers have traded on the way Hoosiers are supposed to talk, employing *ain't*s and *thankee*s and *kin*s and apostrophes to try to phoneticize the quaintness, but that is a vain and condescending practice. If you want to hear how Hoosiers really sound, you just have to come and listen to them, in all parts of the state. After a couple of generations of network broadcasting's homogenizing effect, Hoosiers pronounce words pretty much the way most folks do, except for some of us elders. It was not so much the pronunciations, anyway, as the idioms, the humorous undertones, the terms and the phrasings, that made Hoosier speech distinct.

"How you doing, neighbor?"

"Oh tol'able. How about you?"

"Well, I was better, but I got over it."

Or hear an old Owen County sawmill hand and bluegrass picker narrating a ghastly accident from his past, half-smiling as he goes, "Reckon my brains were still out to lunch. I leaned agin that log carriage while the saw was a-runnin'. Next thing, I was right on that saw feet first. Ripsawed my leg like an old log, plumb up to my straddle." He shakes his head and adds, "So, well, now I got me this funny drawed-up leg, makes me hitch along like a slope mule. But it's just right to prop a banjo on. Things work out, don't they?"

Once when James Whitcomb Riley was attending a long-winded lecture on the definition of art, he leaned close to the man in the next chair and confided, "Speakin' o' art—I know a feller over't Terre Haute that can spit clean over a box car."

Now that is the very essence of *Hoosier.* There are lectures on art in Indiana, regardless of what the rest of the country thinks of "Hoosier hicks," and the Hoosier is there because art matters to him. But when a Hoosier is subjected to too much long-winded seriousness about a given subject, his Hoosierness calls upon him to go droll and play the hick a little, lest he seem to be too serious about artsy things. After all, no Hoosier wants himself or his thoughts on anything to get trapped in one spot, because the *mystique* of being Hoosier is like the gray fox. To be defined in a strict way is to be caught.

Although it is true that Brown County was the seat of a superb and serious group of American Impressionist painters,

the county most enjoyed its reputation as being a center of cracker-barrel philosophy.

It is true that Indiana was a hotbed of the Ku Klux Klan, but it was also a route of the Underground Railroad; furthermore, it was the first state in the U.S. where a judge ever hanged white men for murdering an Indian.

It is true that Indiana gave birth and nurture to an astonishing share of the most successful authors in America, but most of them went elsewhere to write about what Indiana meant to them.

It is true that Indiana is still thought of as the corn-and-hog state, even though it has been one of the nation's fountainheads of finance, insurance, manufacturing, and invention—including invention of the gasoline automobile, the carburetor, the gasoline pump, the automobile heater, and the blood alcohol tester—all of which advanced and influenced the automobile industry and changed the whole American way of life.

It is true that Indiana has put in Washington an unequaled succession of undistinguished vice-presidents, but it has also put into space many astronauts—twenty-one of them educated at Purdue University—and produced a good share of Nobel and Pulitzer Prize winners in many fields. Remember, too, the co-inventor of powered flight, Wilbur Wright, was born a Hoosier.

In the realm of swords and plowshares, it is true that the Gatling Gun was invented in Indianapolis, and millions of weapons of war were manufactured in Indiana. But the famous "plow that broke the Plains" was developed by James Oliver of South Bend; the first plow on wheels was invented by Hoosier Asa Fitch; and the first mechanical corn picker was made by John Powell of Kokomo. Those things changed agriculture and have helped feed the world. Hoosiers have made a difference in this country, on this globe.

Heading into its third century as a state, Indiana becomes even less distinguishable to the passing eye: homogenized by Interstate bypasses, chain stores, chain motels, chain filling stations, chain restaurants; its opinions and dialects standardized by exposure to the mass culture of television. Indiana blends in with its neighboring states even more, and tends even more to be a stretch of "Ohiowa," in the view of the traveler.

Even for its own citizens, Indiana is disappearing, as knowledge of its peculiar history fades. Hoosier students fail to learn about its Golden Ages of industry, literature, and music, its Dark Ages of racism and labor war and Depression.

There are high school students now who can name only Bobby Knight and John Cougar Mellencamp as famous Hoosiers; they cannot even tell you which side the state fought on in the Civil War. They are ignorant of the fact that this was the state where every city wanted to be important but yearned to be thought of warmly as a small town; the state that once went bankrupt over canal financing and became so fiscally conservative that the state budget still comes up with

huge surpluses; the state whose patriotism was so staunch that the American Legion chose to headquarter itself here; the state that might have remained the automobile manufacturing capital of the world except that Hoosier magnates were so suspicious of outside capital, immigrant workers, and labor unions that the opportunities went elsewhere; the state that resisted legalized gambling as immoral and dangerous until half the states were legalizing it; the state that was so contrary and independent with regard to federal aid that it held back its urban development for years.

Indiana has always been a puzzle, a place to make observers scratch their heads. But now it is more and more like all the other states. Once touted for its "averageness," it is being overtaken by the rest of the country in averageness, and only Texas and California seem to cause head-scratching any more.

The traits of a people are formed by the land where their roots are. Back in the days when a Hoosier was a distinct and peculiar kind of a person, Hoosiers were still close to the land of their roots.

Nowadays the huge majority of the population is so remote from connection with the land, and so mobile, with so few moderns remaining in their homelands, that a Hoosier grows vague of outline, more like any American. It is doubtful that much of the new generation will ever even feel that they are Hoosiers; that is just the name of the I.U. basketball team. What was pridefully known as the Hoosier Dome in Indianapolis has changed its name to the RCA Dome.

Until Indiana and Hoosierness fully dissolve into the general, anonymous American identity, however, those of us who were brought up feeling Hoosier will go on being Hoosiers, pretending to be modest about it and smiling a foxy, one-sided smile.

We know: Indiana may be low in profile, but it is high in significance, so much so that a Hoosier could be a Texan if he wanted to—but o' course, he don't.

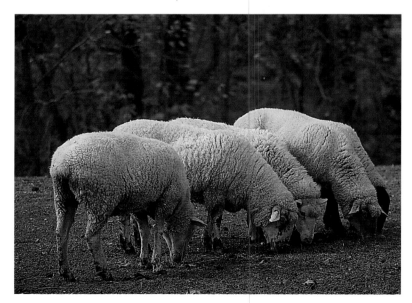

△ *Where bison, elk, and white-tail deer once grazed, sheep now crop Parke County pastures. Such timeless bucolic scenes are interwoven with highways, cities, mines, factories, and telecommunication towers as Indiana evolves into the twenty-first century.*

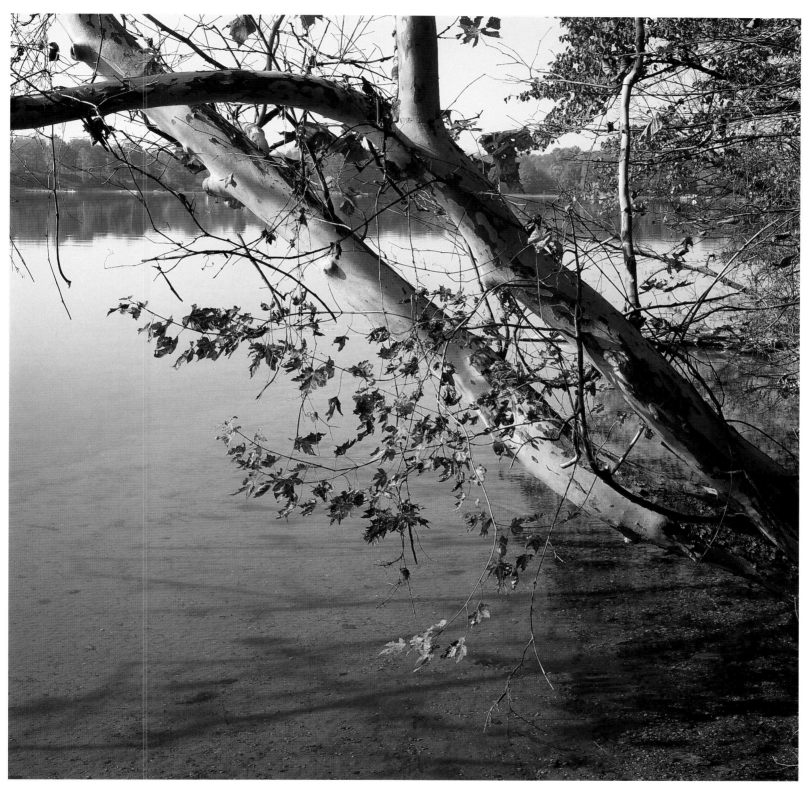

△ Northern Indiana's profusion of linked lakes was created by the weight and gouging force of Ice Age glaciers which covered much of the state until about ten thousand years ago. Where Miami and Potawatomi villages once flourished on the lakeshores, resort hotels, boating and swimming clubs, amusement parks, dance halls, and the summer homes of Hoosier tycoons grew up to take their place for a century. Crooked lake, shown here, is Indiana's deepest glacial lake.

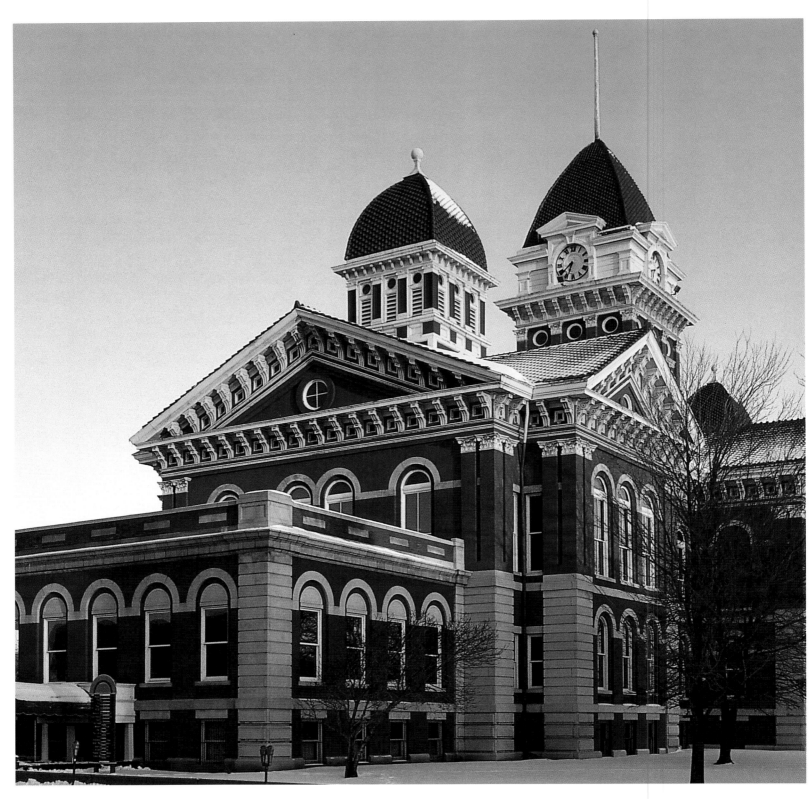

△ Romantic as well as Romanesque, the old Lake
County Courthouse at Crown Point is where silent
screen lover Rudolph Valentino obtained his marriage
license in 1923. The renovated courthouse houses
a historical museum, restaurants, and boutiques.
▷ Its age counted in centuries, the Council Oak in
South Bend's Highland Cemetery is said to be the
tree under which explorer Robert Cavalier de La
Salle persuaded the Illinois and Miami Indians to
ally with the French against the Iroquois in 1681.

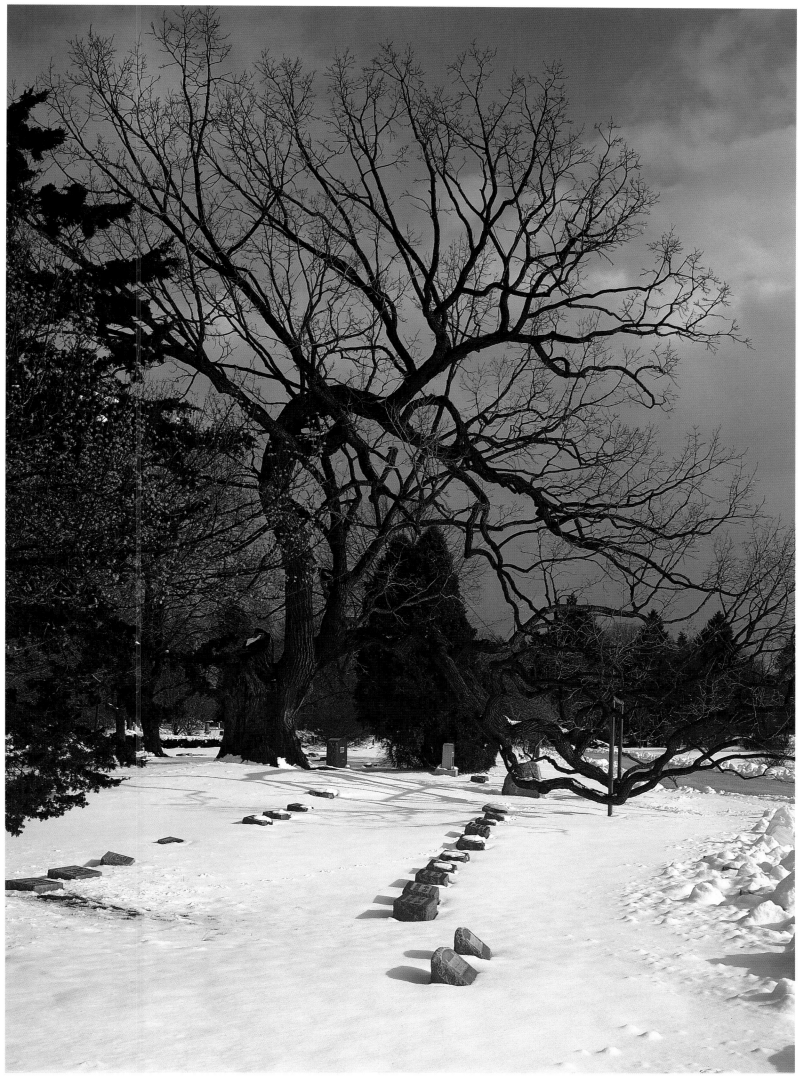

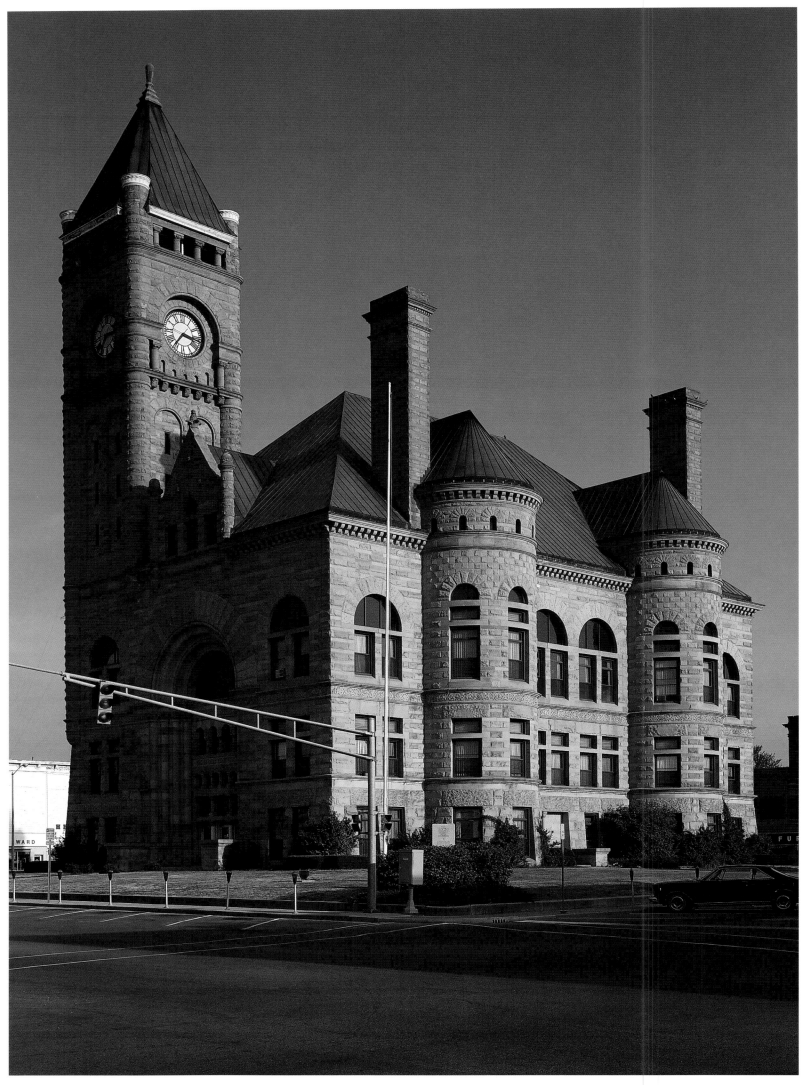

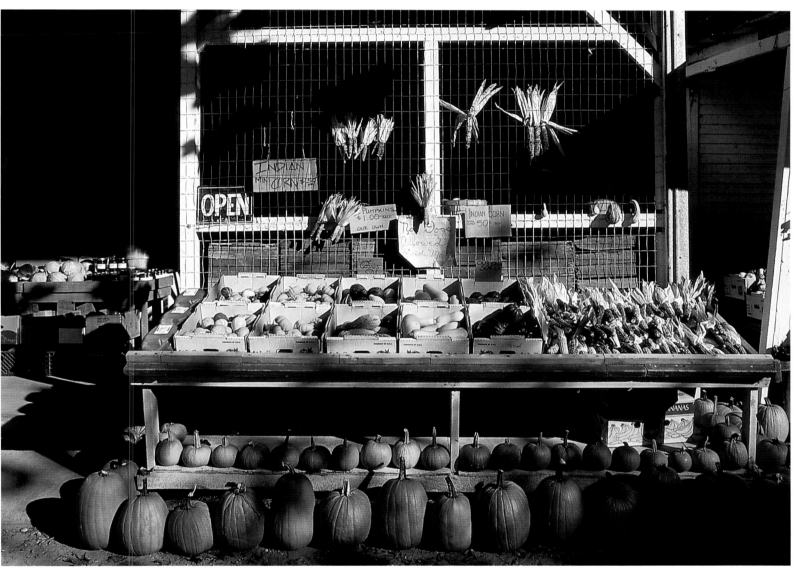

◁ Featuring the semicircular stone turrets common to several late-nineteenth-century courthouses, Blackford County's grand limestone courthouse at Hartford City was built during a glass and paper manufacturing boom fueled by the discovery of natural gas in 1887. △ At roadside farmstands, traditional Native American crops such as corn, beans, squash, and pumpkins tempt the thousands of travelers bound for the huge Feast of the Hunter's Moon encampment at Fort Ouiatanon near West Lafayette.

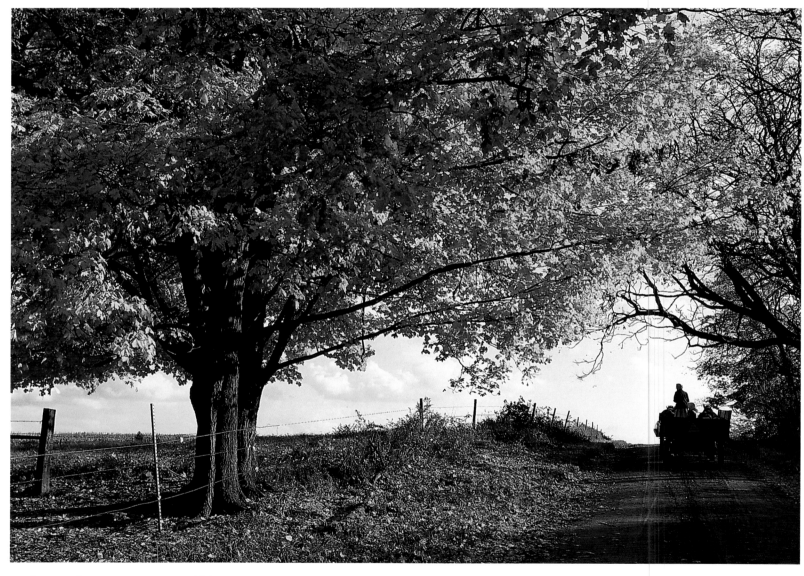

△ The past lingers in names and lifeways near
Shipshewana, where Amish farmers still take their
goods to market in horsedrawn wagons. Meaning
"vision of a lion," Shipshewana was a Potawatomi
chief who was forced to move his tribe from here to a
Kansas reservation in 1838, but returned to his home-
land to die three years later. ▷ Steuben County, once
a rich fur-trading and lake-fishing area, was named
after Prussian-born Baron von Steuben, who trained
George Washington's ragged troops at Valley Forge.

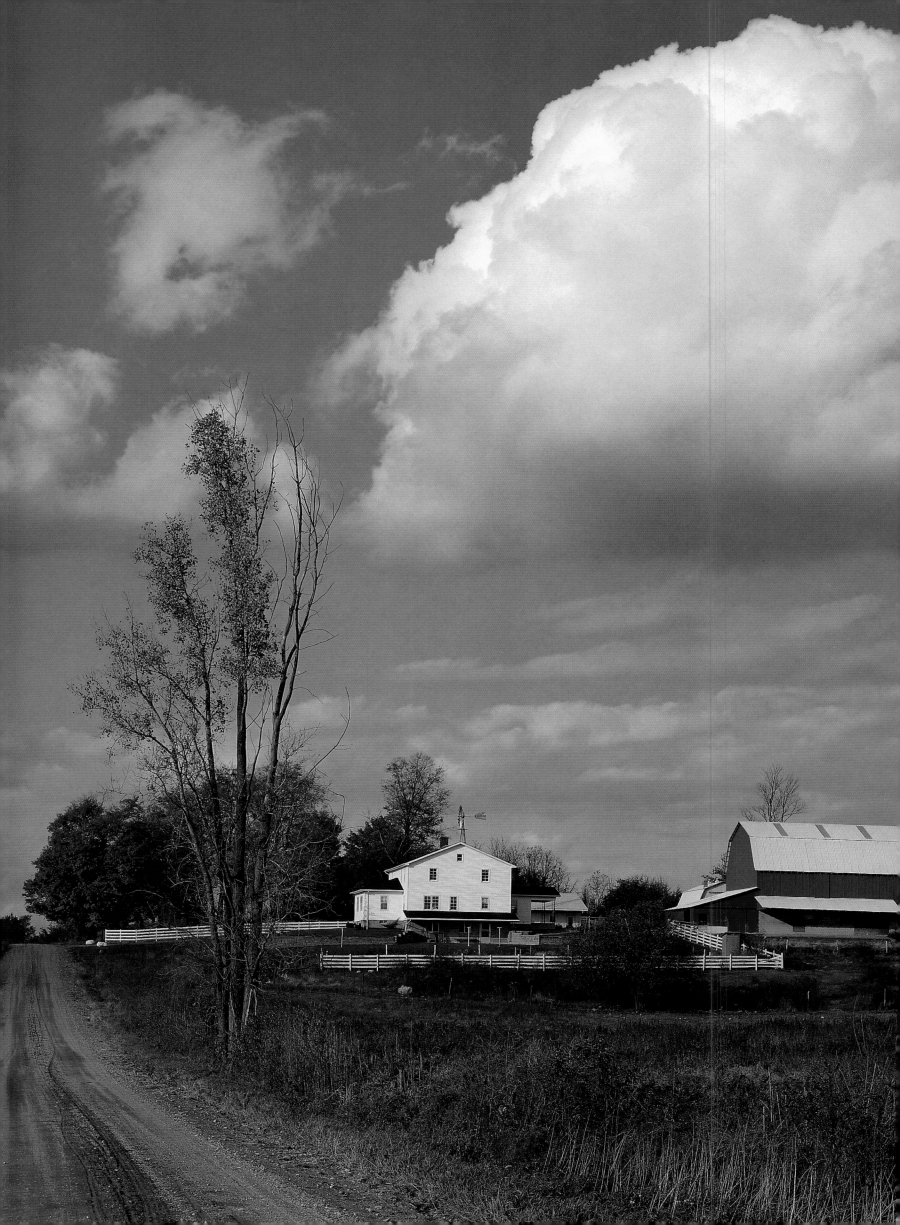

◁ Americans could study the productive, peaceful, and orderly Amish who settled many rural Indiana areas, such as this farm in Lagrange County. △ After bad train connections and breakdowns forced New York *Tribune* publisher Horace Greeley to ride a handcar all night through the spooky Grand Marsh of the Kankakee, he could never say a good word for Indiana. This protected wetland is the last vestige of that half-million-acre swamp. ▷▷ A canoeist attempts a camouflage paint job for lake reeds in the shallows of a glacial lake.

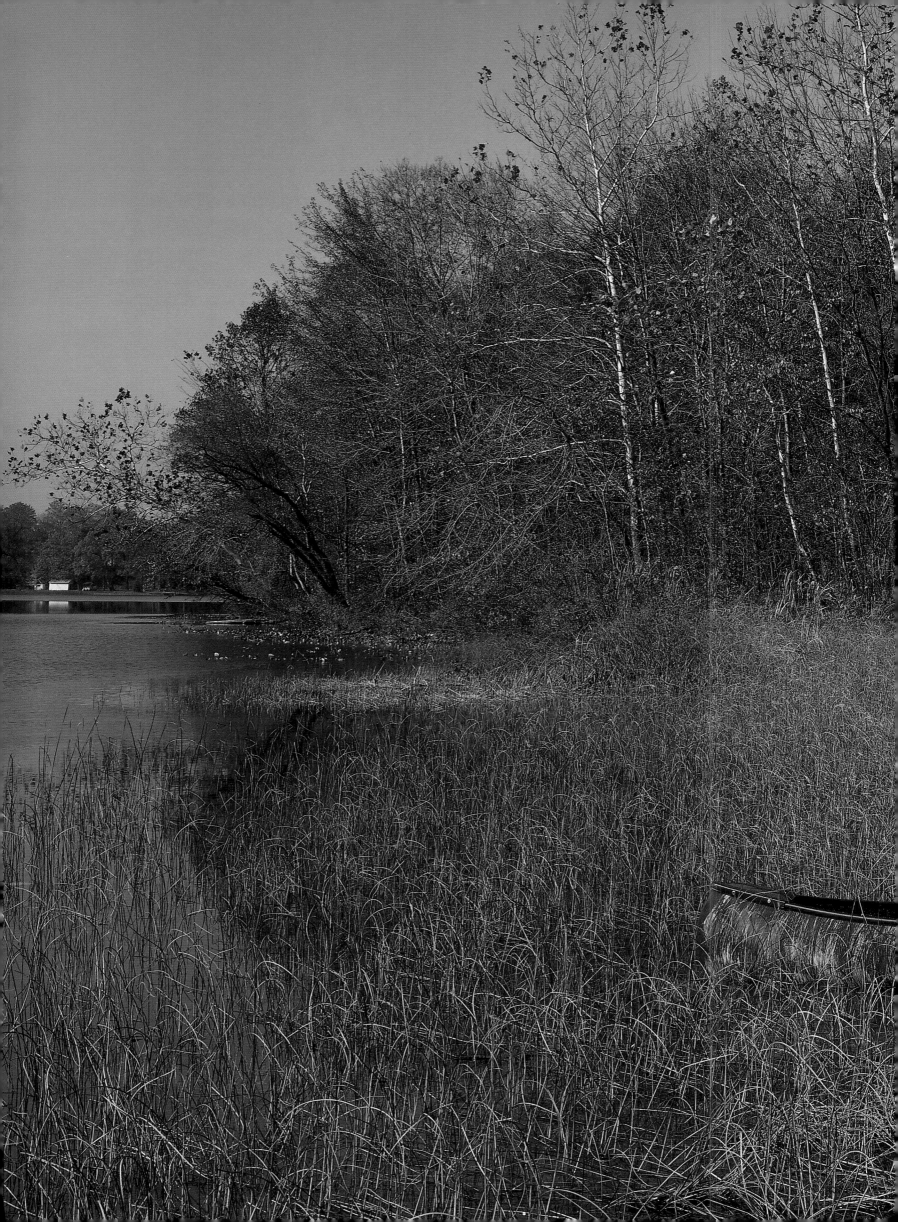

△ An angled branch in the woods at Pokagon State Park is reminiscent of Woodland Indian trail marking devices. ▷ Miami tribal people from Oklahoma return to their Wabash homeland in June every year for the Miami pow-wow at Huntington, near the historic home of Chief Jean Baptiste Richardville, or Peshewa (Wildcat), whose Fort Wayne trading post and sale of tribal lands made him the richest Indian in America before his death in 1841. An active tribe of Indiana Miamis, based in Peru, has long campaigned for Federal recognition—so far in vain.

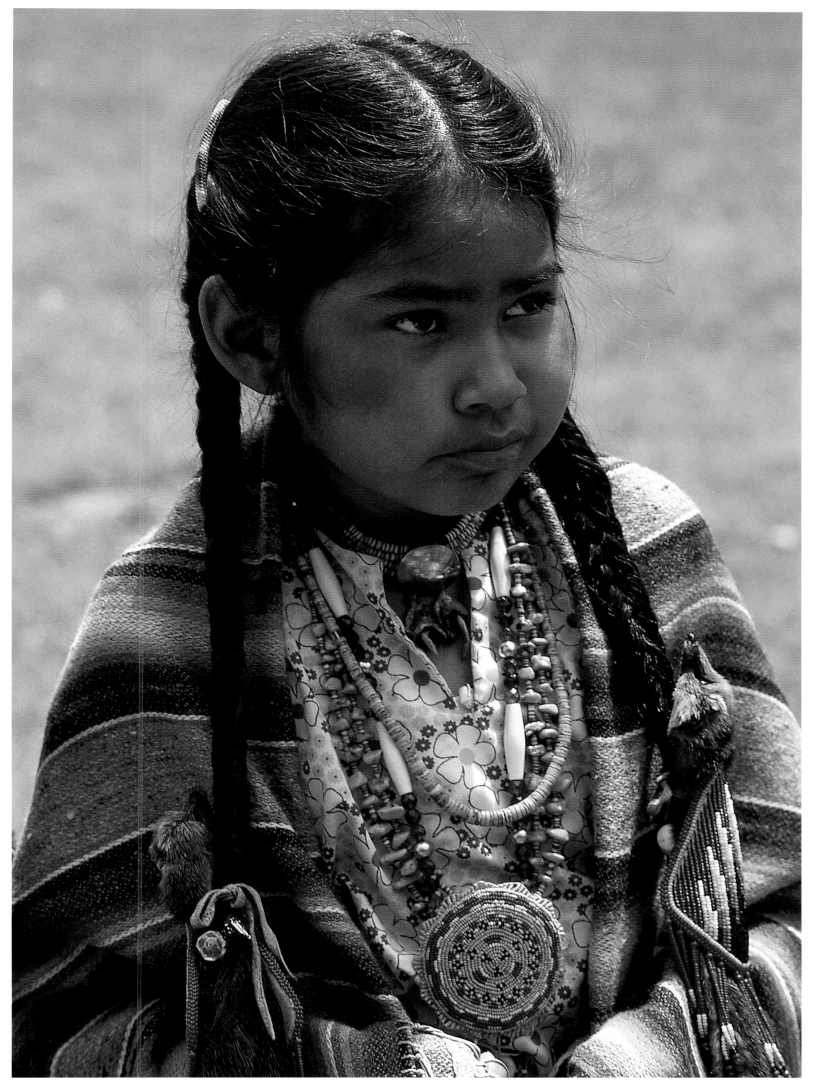

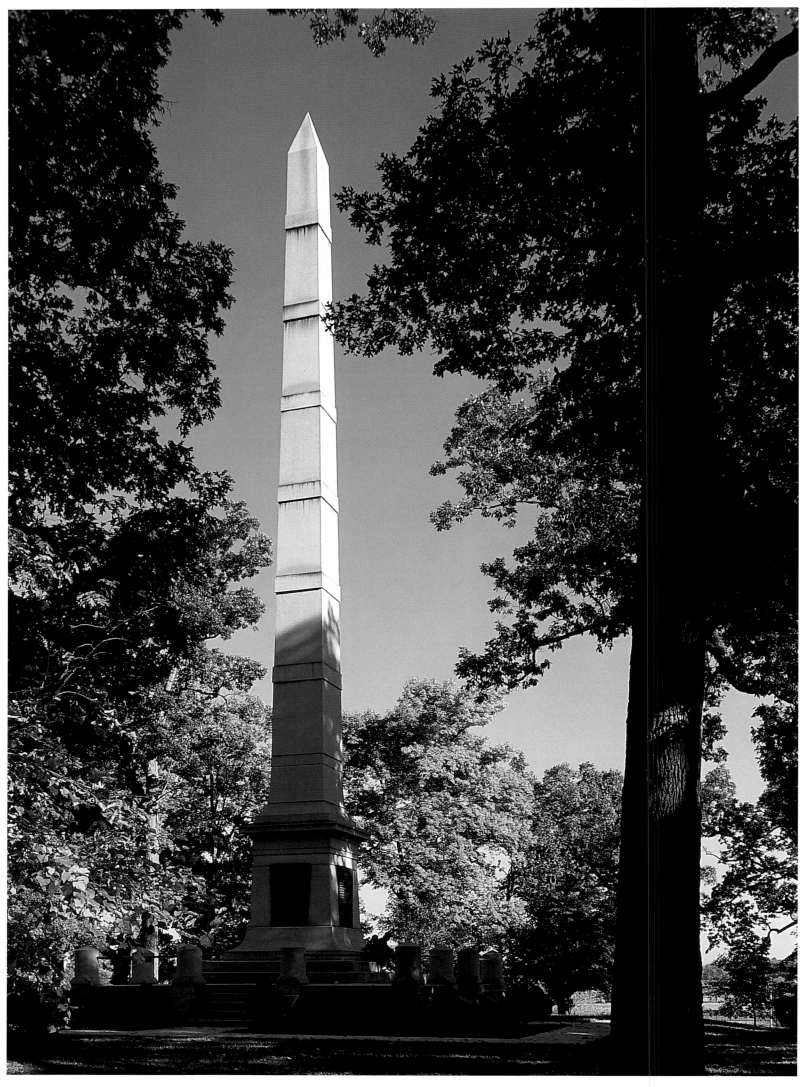

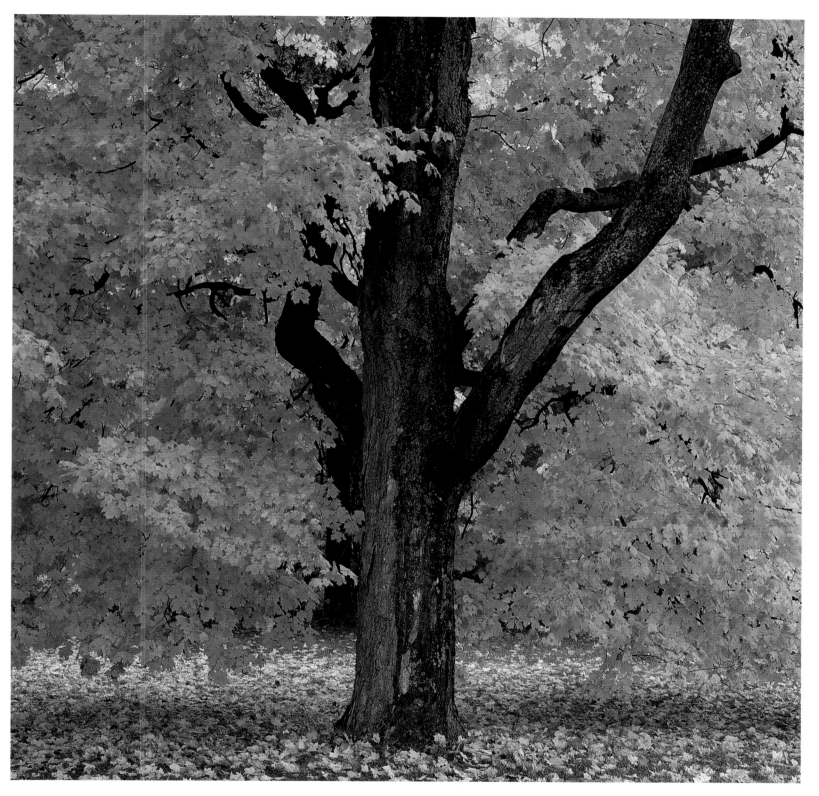

◁ Some old trees still bear scars from musketballs and arrows that flew on November 7, 1811, when warriors inspired by the Shawnee Prophet Tenskwatawa surprised an American army that threatened the Prophet's holy town. An obelisk on the Tippecanoe battleground honors American officers killed in the pre-dawn attack. Indiana territory governor William Henry Harrison, who led the troops, later campaigned successfully for the presidency as "the Hero of Tippecanoe." △ Maple syrup and sugar are made each spring by Hoosiers from the sap of the glorious maple tree.

45

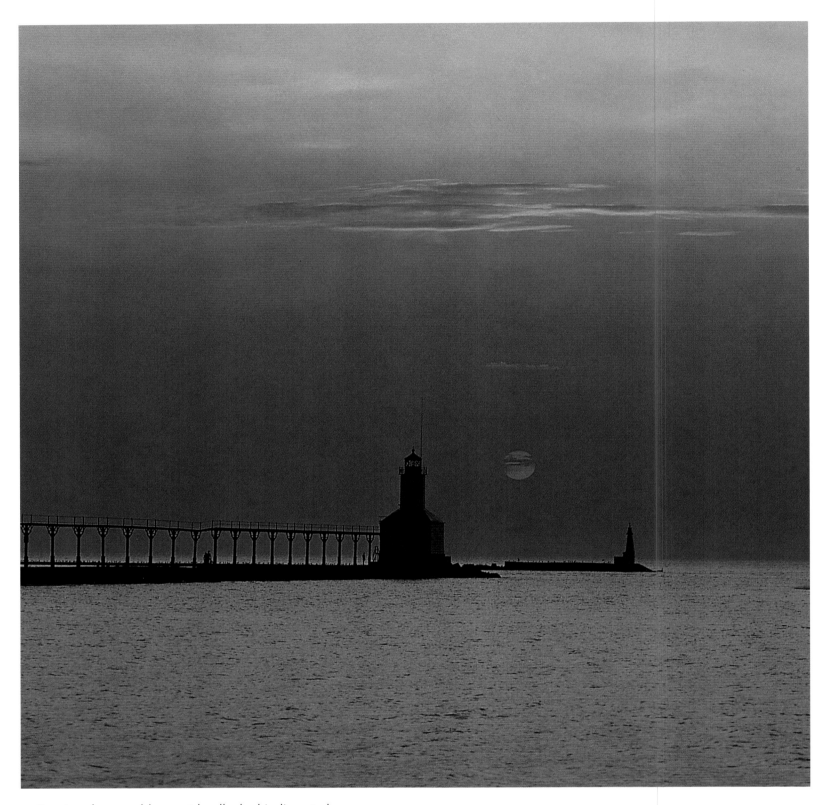

△ Few travelers would expect landlocked Indiana to have
a lighthouse, but this one functions at Michigan City, at
Lake Michigan's lower tip, where Great Lakes maritime
shipping reaches Hoosier shores. ▷ Hoosiers can still
hear the songs of wolves at dusk by going to Wolf Park,
near Battleground, Indiana. Here, Dr. Erich Klinghammer
of Purdue University maintains a pack, enabling scientists
and students to study the social behavior of these highly
intelligent canines. Visitors can "adopt" park wolves
by paying small fees to contribute to their support.

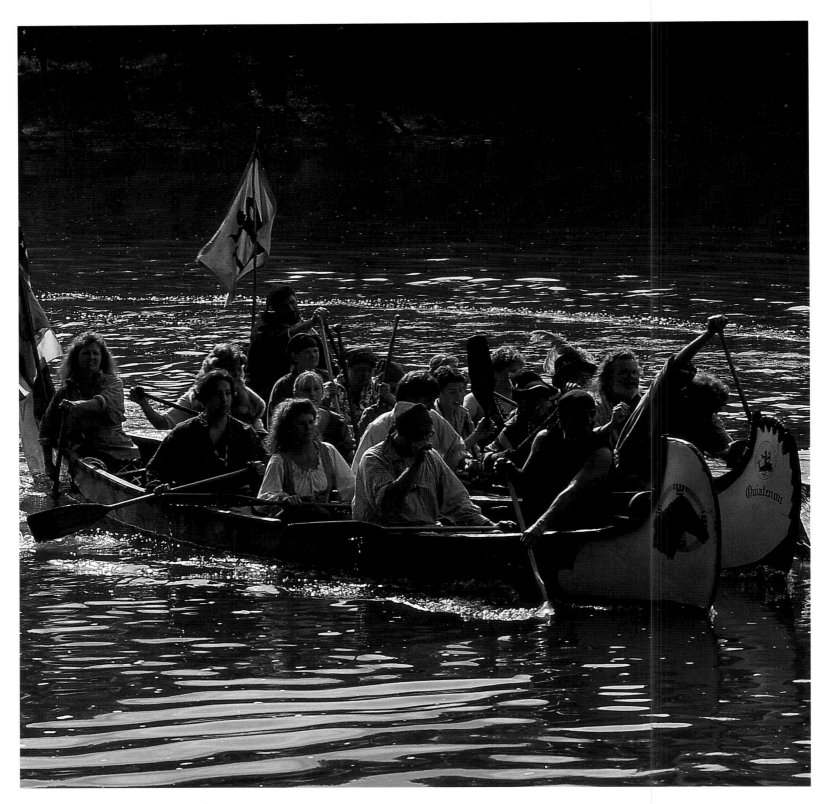

△ Reenactors stage a voyageurs' canoe race on the Wabash River each year during the thronging autumn encampment known as the Feast of the Hunter's Moon. ▷ Wild turkeys used to perch on ledges in the water-carved Rocky Hollow Canyon; they inspired the name of Turkey Run State Park, home of one of the largest tracts of virgin woods remaining in the state. Of the estimated twelve million acres of virgin woods with which Indiana was once covered, only about fifteen hundred remain.

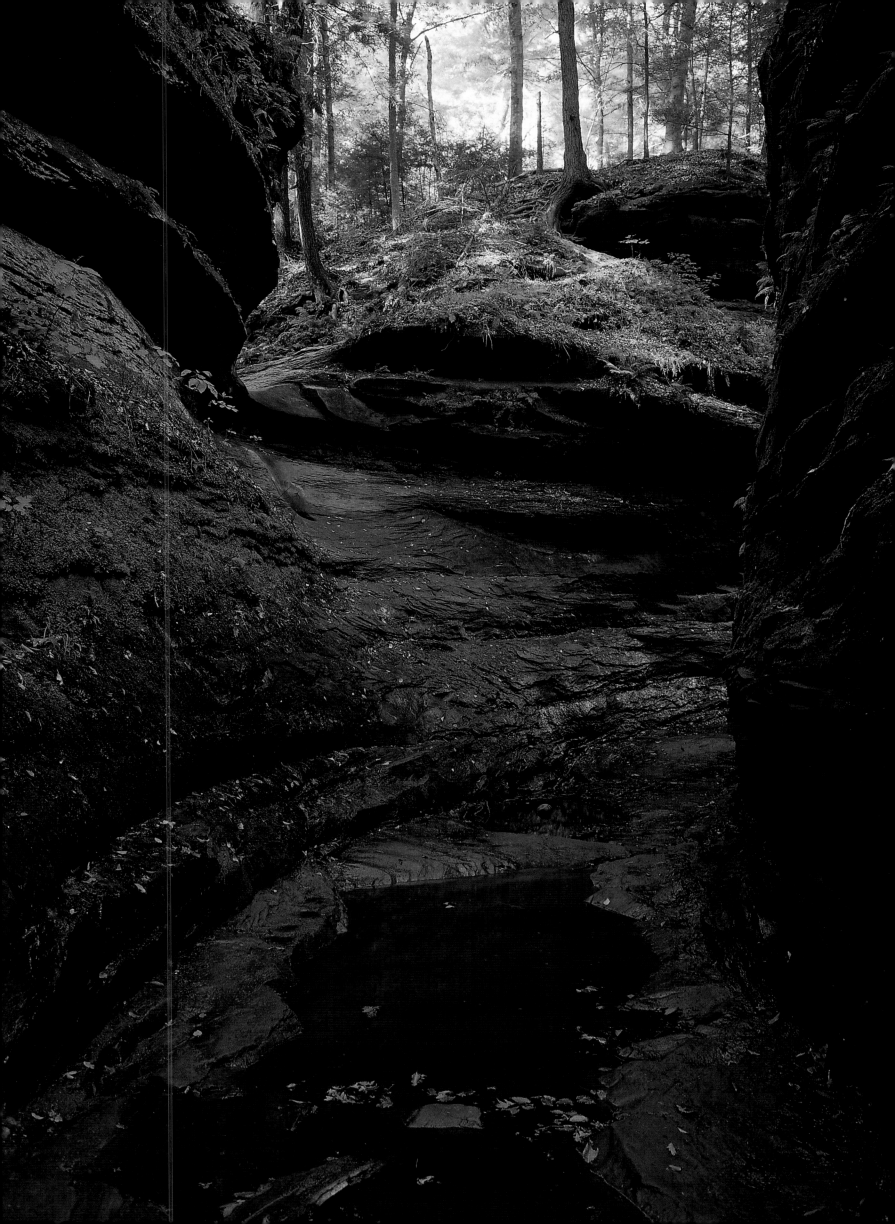

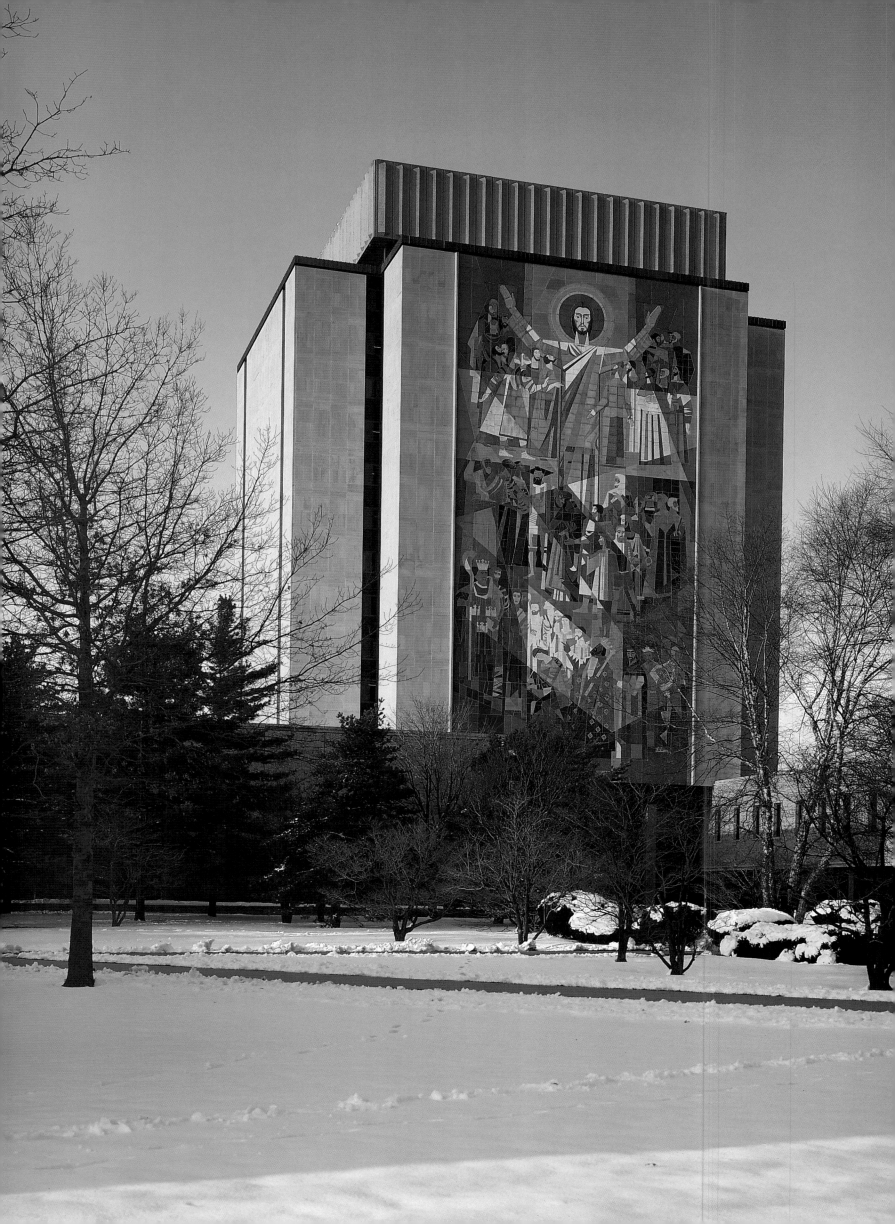

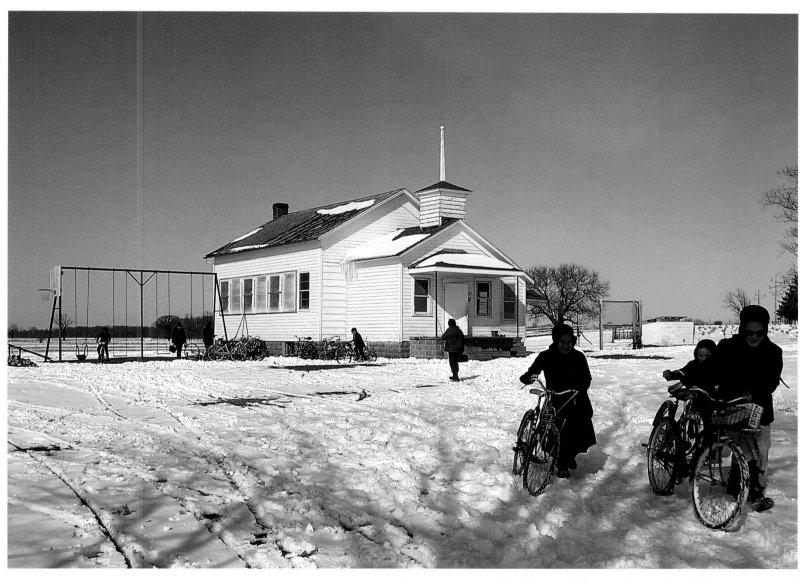

◁ *The Word of Life* mural, 134 feet high, covers a wall of the Notre Dame Memorial Library. Muralist Millard Sheets gathered 6,700 pieces of granite in 143 natural shades from 16 different countries to make the mosaic. △ Amish schoolgirls leave their windswept little schoolhouse near Nappanee. ▷▷ Papakeechie Lake was six small lakes surrounded by marshland before construction of an earthen dam in 1910. Named for Miami chief Papakeechie, it is at the south end of a more famous lake named for his more famous brother, Wawasee.

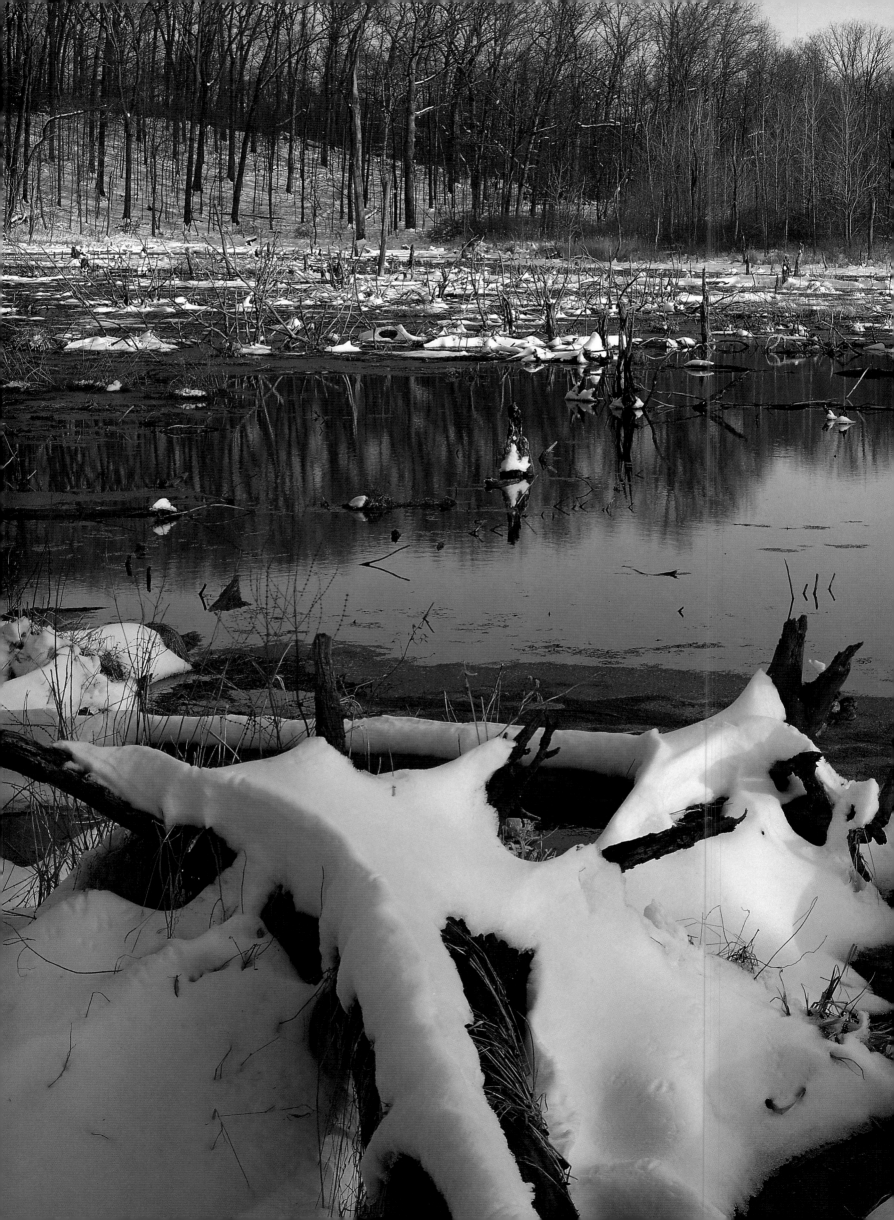

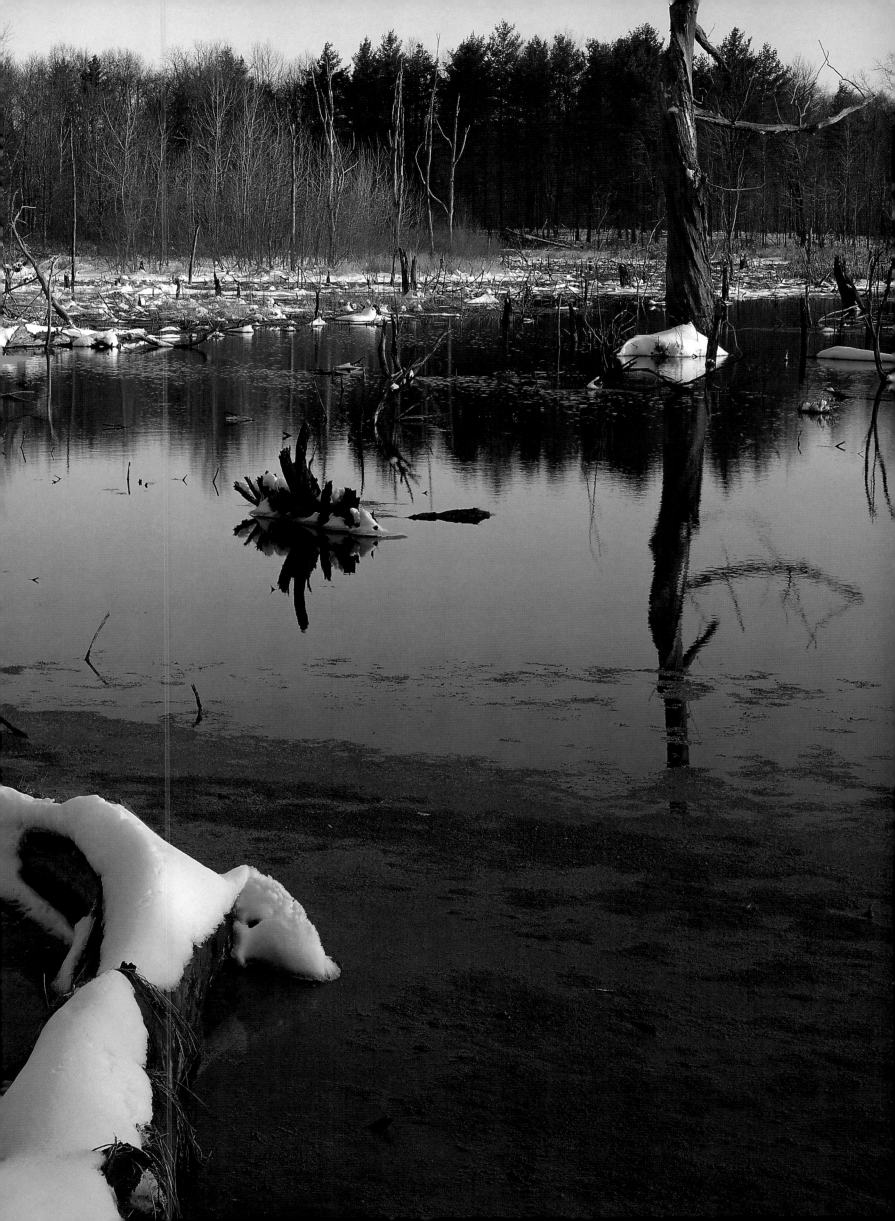

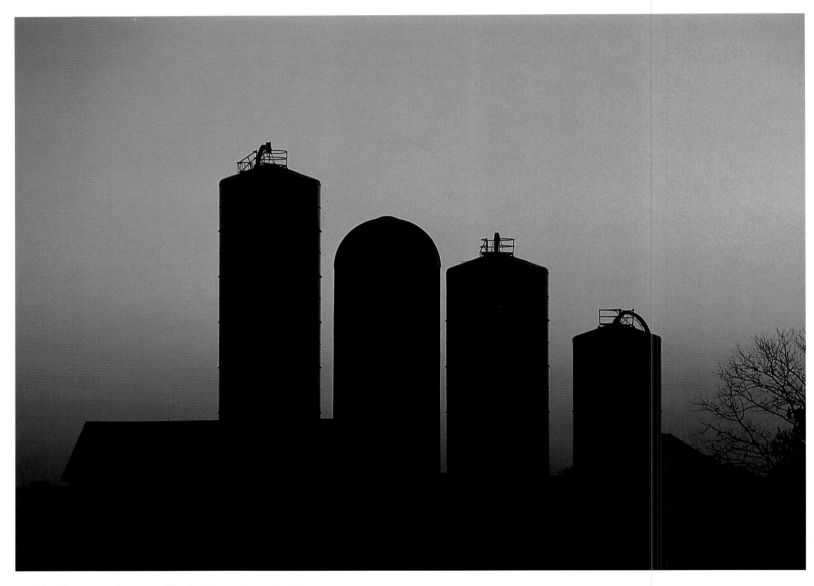

△ Silos loom against a twilit sky in northern Indiana.
▷ Named after General "Mad Anthony" Wayne, Fort
Wayne guarded the portage between the Maumee River
route to Lake Erie and the Wabash River route to the
Ohio and Mississippi. This reconstruction of the two-
story fort stands where the St. Mary's and St. Joseph
Rivers converge to form the Maumee. ▷▷ Almost a
full acre of exotic, endangered, or simply beautiful
plants thrive under a glass roof at the Foellinger-
Freimann Botanical Conservatory in Fort Wayne.

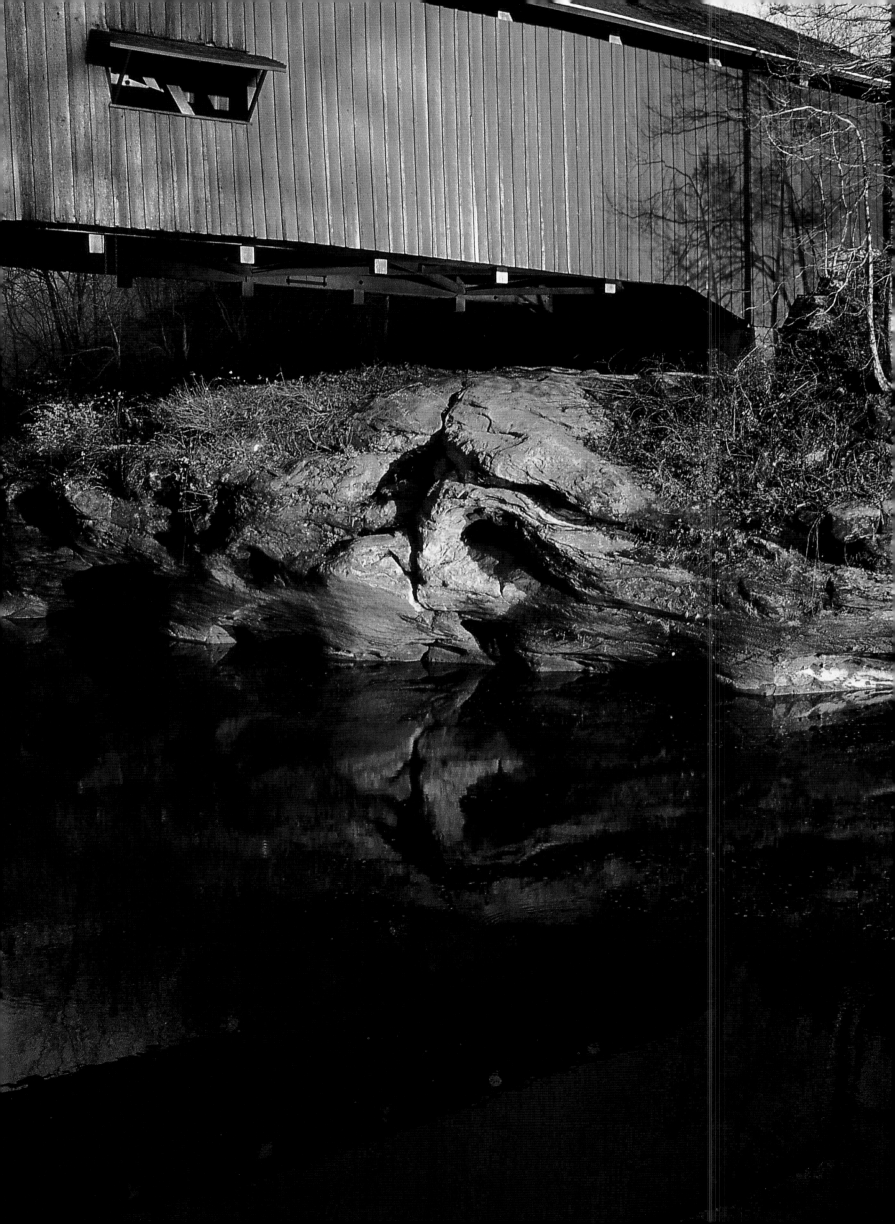

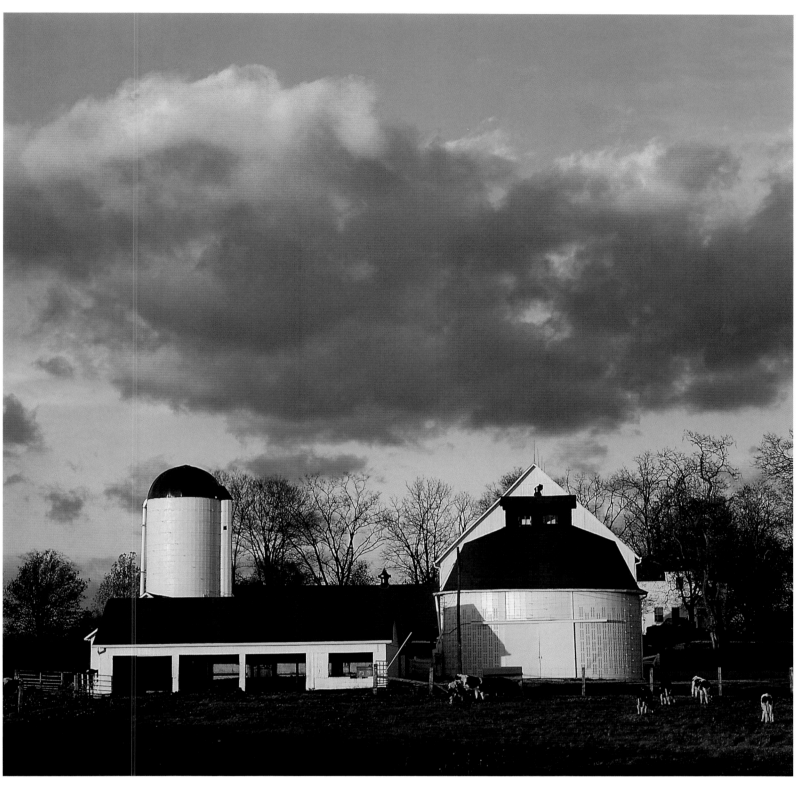

◁ Sugar Creek, flowing between sculpted stone banks, is one of the state's most popular canoeing streams—not for its whitewater thrills but for the natural beauties that lie along its westering way to the Wabash. △ The architecture of farms is, by necessity, based on utility, but often results in geometric beauty, like this cluster of curved and angled buildings that is visible from a busy highway in northwest Marion County, a mere dozen miles from the state's capital.

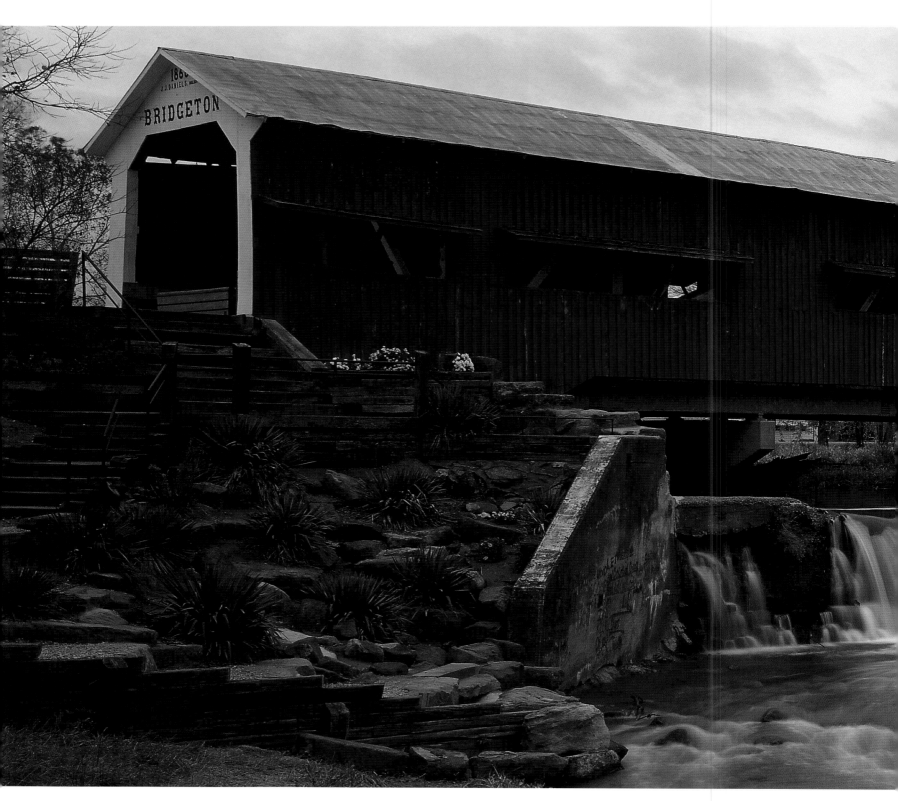

△ Raccoon Creek, here spilling under a covered bridge at Bridgeton, assumed historical importance in 1809 when its junction with the Wabash was picked as the base point for the boundary of lands to be taken from the Indiana Indians by treaty. Shawnee war chief Tecumseh's adamant objection to that so-called 10 O'clock Treaty Line led to his life-and-death struggle against General William Henry Harrison, whose troups killed Tecumseh in the War of 1812.

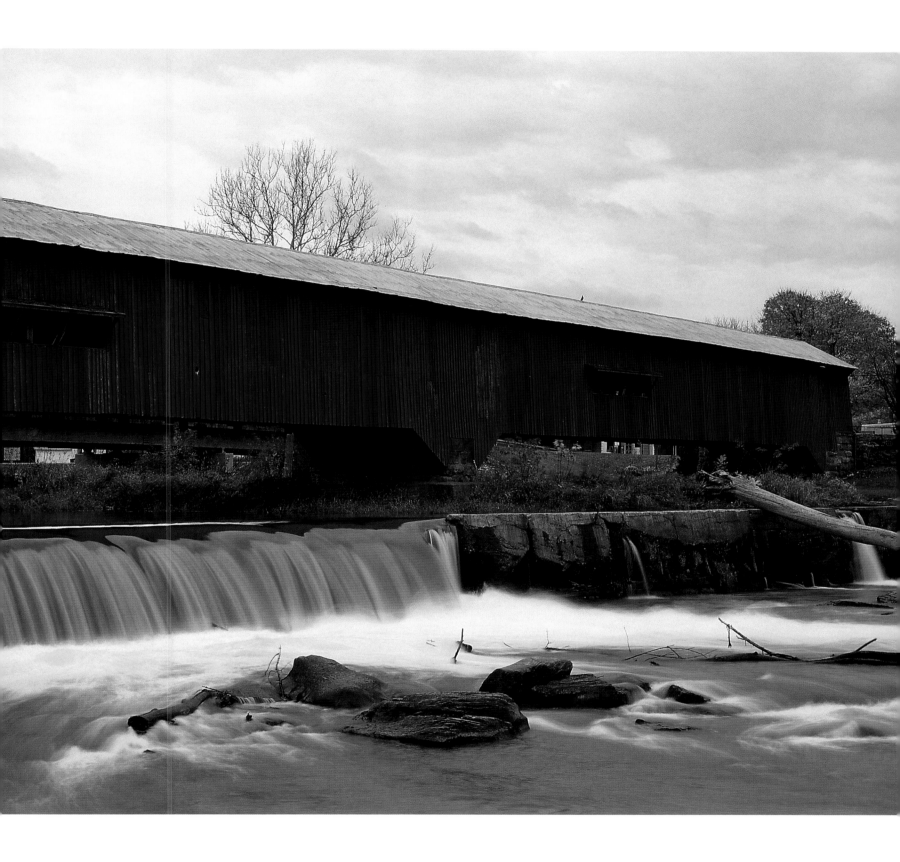

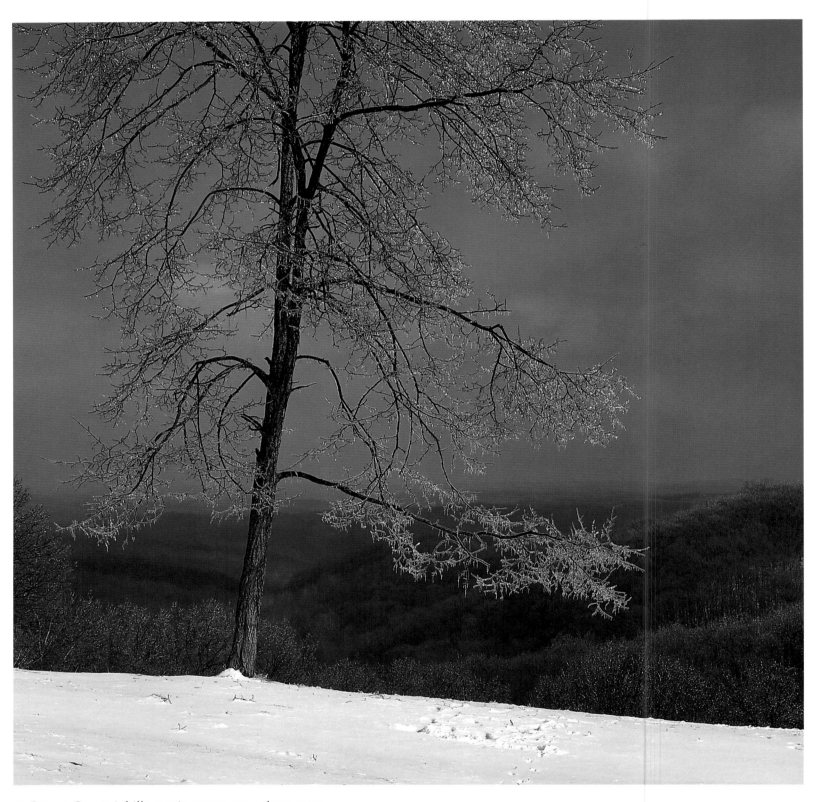

△ Brown County's hills, rustic towns, art colony, state park, and ski facilities make this south central county a magnet for tourists year-round. Steep terrain and hazy distances have earned this region the nickname "Little Smokies." ▷ Most famous for its breathtaking autumn foliage, the Hoosier hill terrain reveals its contours in winter when branches are bare. Called *karst* country by geologists, the limestone hills of south central Indiana are characterized by V-shaped gullies, sinkholes, caves, and underground streams.

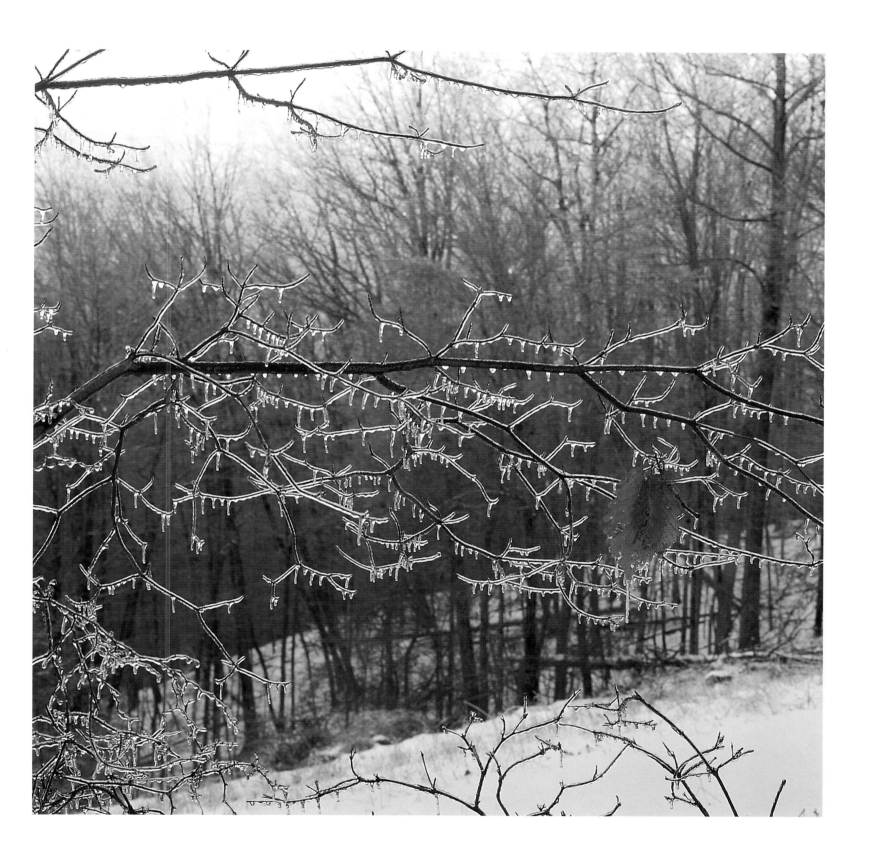

△ This old church reflects Indiana's fundamental religious attitudes—an inflexible moral sense many intellectuals, artists, and authors found so stifling that they moved away. Ironically, self-exiled Hoosier authors have written a large proportion of the nation's literature. ▷ This elegant building in Crawfordsville was the study where General Lew Wallace worked on the autobiography published after his death. His best-known work, *Ben Hur,* was published while he was governor of the New Mexico Territory, but much of it was penned under a huge beech tree near this study.

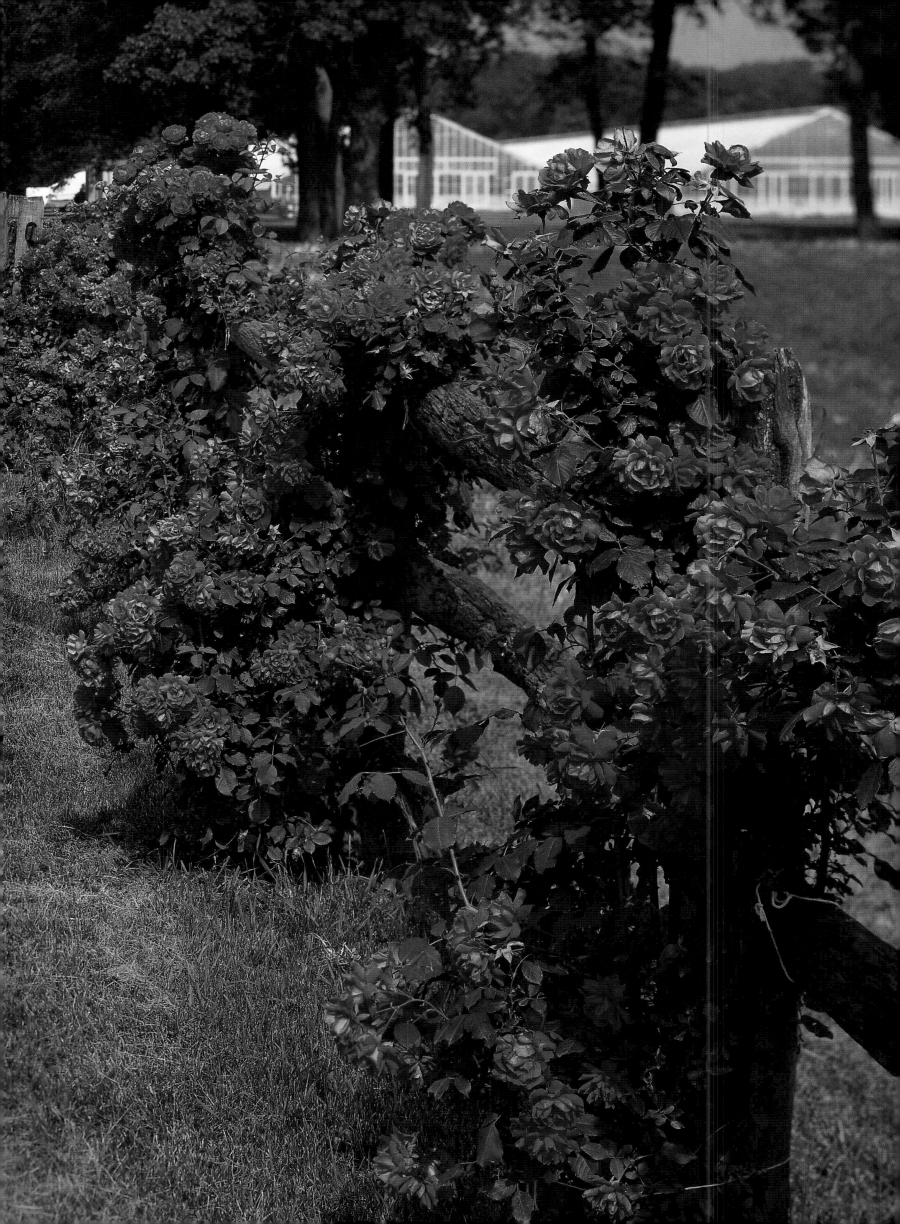

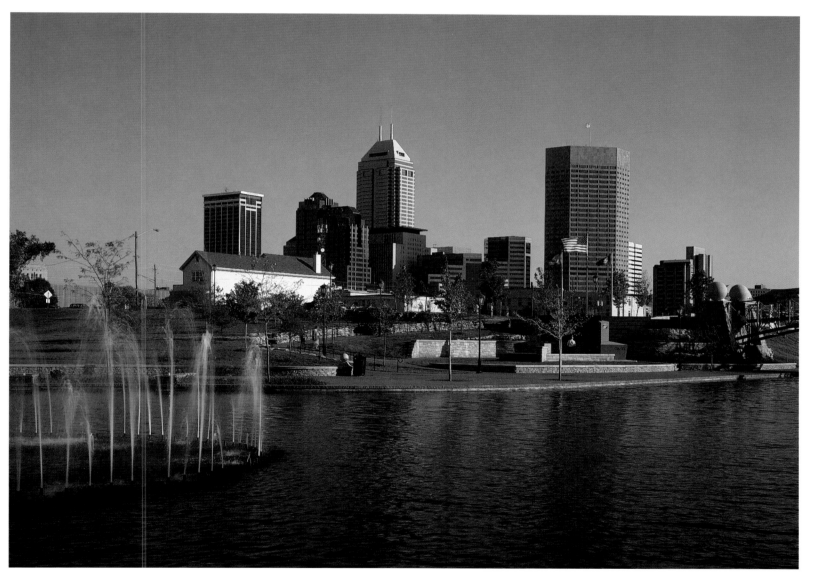

◁ A large proportion of the world's rose varieties were developed by the Hill rose companies in Richmond.
△ Fountains play in a part of the old Central Canal, renovated in the last decade after being maligned for years as "that foul-smelling ditch." The site offers a good view of the burgeoning skyline of Indianapolis. The capital city might have been named Tecumseh, after the admired Shawnee war chief, but that proposal was voted down, and the name Indianapolis was adopted after long debates in which it was ridiculed as "Indiana-no-place."

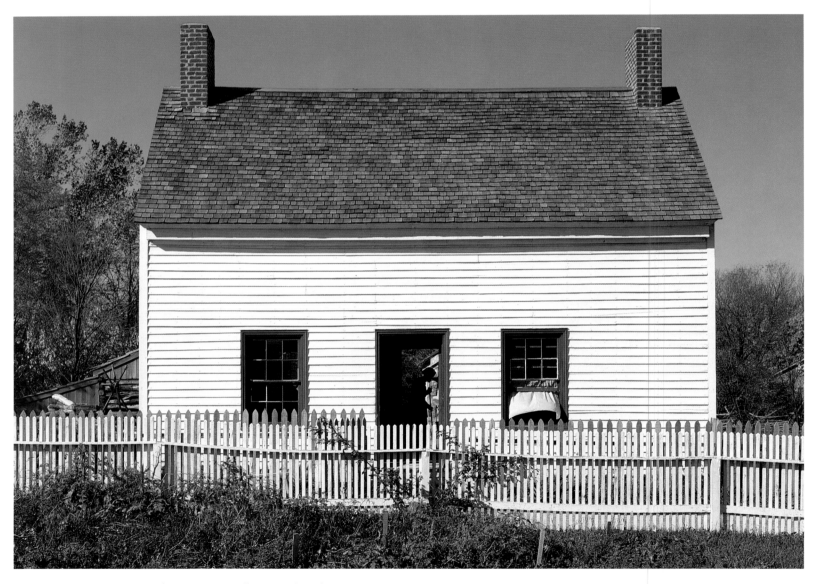

△ An interpreter in period costume is silhouetted in the doorway of a nineteenth-century house at Conner Prairie Pioneer Settlement near Noblesville. The fifty-five-acre out-door museum, with thirty-nine relocated buildings and an $8 million interpretive center, stands where pioneer and fur trader William Conner built a log cabin and trading post on land acquired from the Lenni Lenape (Delaware) tribe in 1802. ▷ Books and handwritten papers of Benjamin Harrison cover the desk in Indianapolis where the twenty-third president of the United States once practiced law.

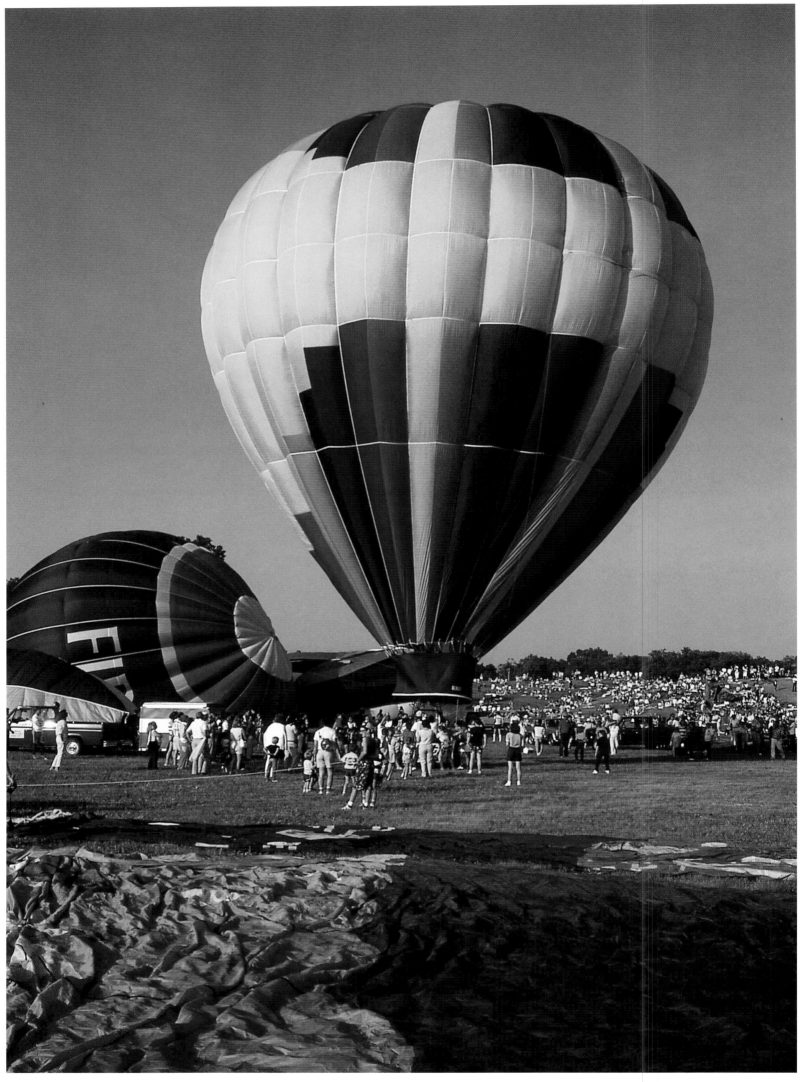

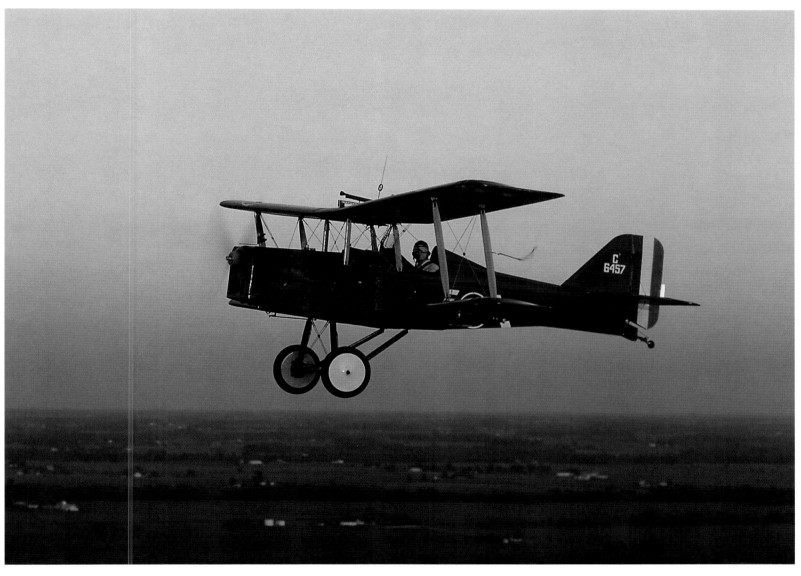

◁ Hot air balloon races, like this one at Conner Prairie, have become a popular and colorful addition to the traditional activities at Hoosier fairs and festivals. △ Morgan County hobbyist Fred Jungclaus pilots his hand-built reproduction of a British SE5A fighter plane from World War I. From Hoosier-born Wilbur Wright to flamboyant airplane racing figure Roscoe Turner to astronauts like Gus Grissom, Indiana has been involved in flight and space travel since the days when man first got off the ground.

△ Lake Wasatch on a quiet fall day typifies
scenic, sparsely populated Owen County, named
after a colonel killed at the Battle of Tippecanoe.
The county has been birthplace and home to
a remarkable number of authors, artists, and
sculptors, including stonecarver Ernest Moore
Viquesney, whose World War I "Doughboy"
statue stands in at least 150 public sites in forty-
two states. The county seat is Spencer, named
after another militia colonel killed at Tippecanoe.

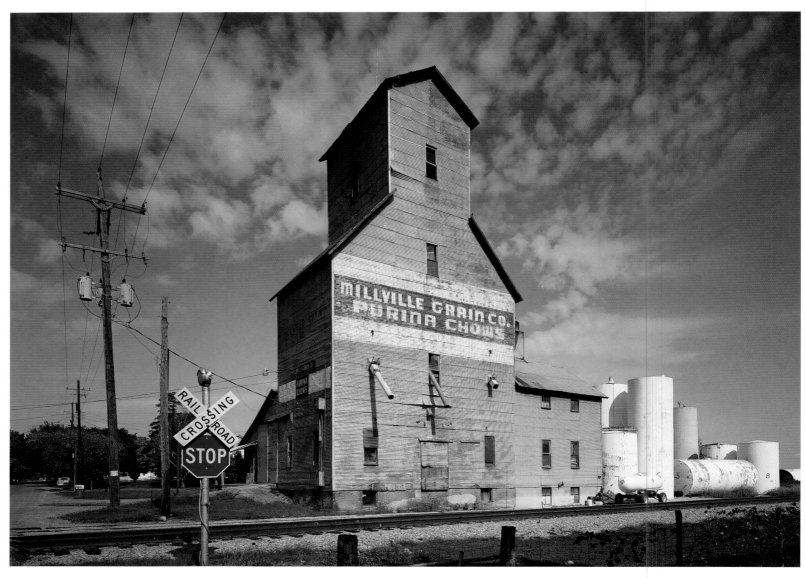

△ At the Henry County hamlet of Millville a grain elevator beside a railroad track makes a scene so Midwestern it could be anywhere from Ohio to Nebraska. In this region east of Indianapolis, three white men were hanged for murdering Indians, the first such punishment in the nation. ▷ Fallen maple leaves gild a canalside path through the estate of pharmaceutical tycoon Eli Lily, now home of the Indianapolis Museum of Art. ▷▷ Such scrub trees as sumac and ailanthus add beauty even to a city lot.

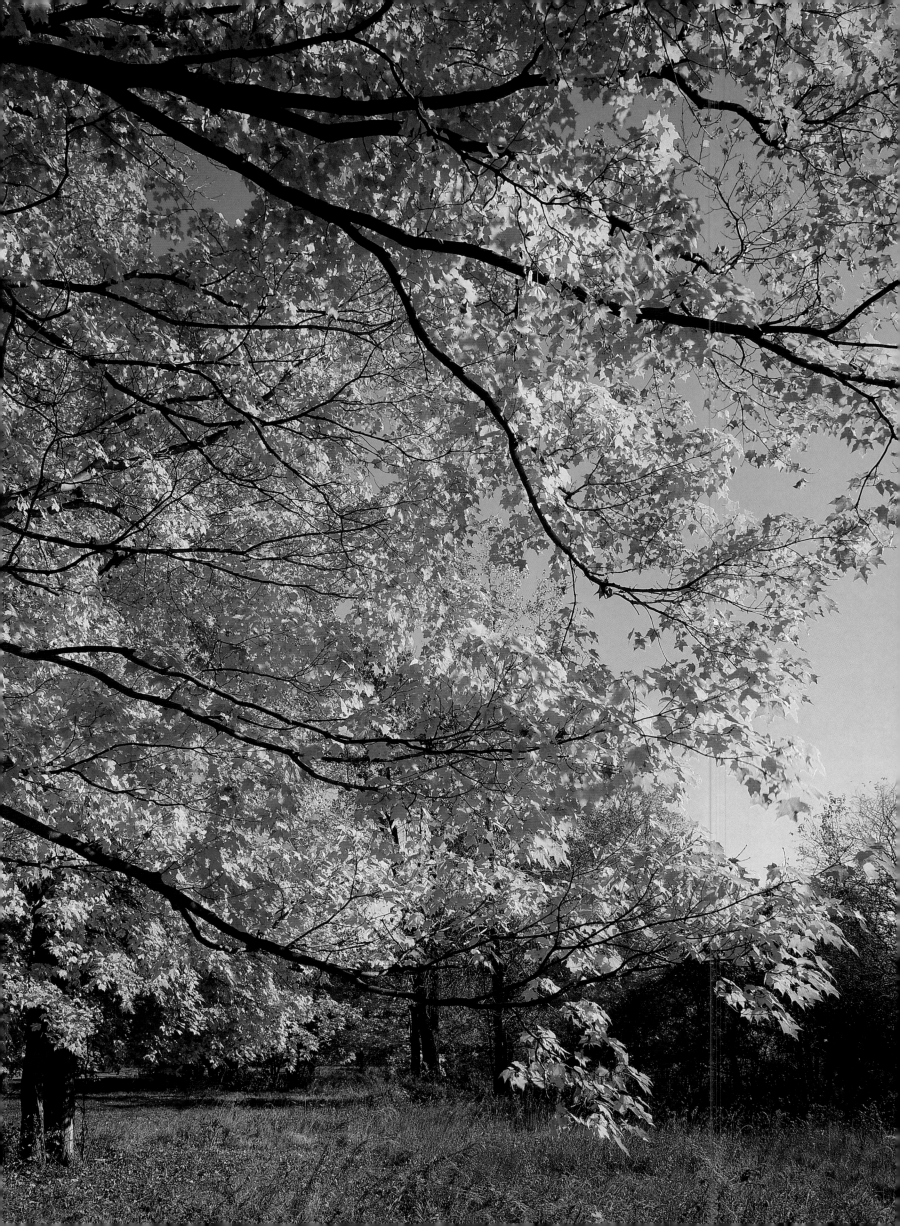

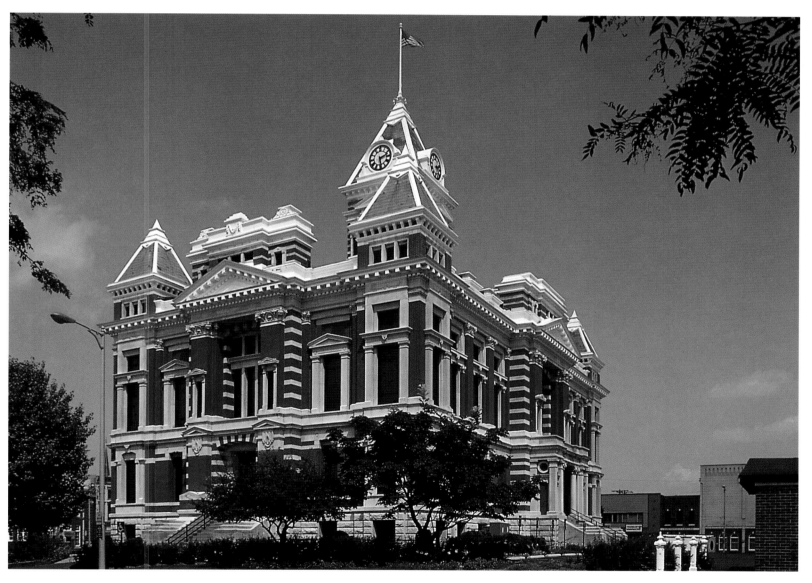

◁ Eagle Creek Park and Nature Preserve in northwest Indianapolis is the largest city-owned park in America, with thirty-five hundred wooded acres and a thirteen-hundred-acre reservoir. △ Two earlier brick courthouse buildings in Franklin burned down before the present handsome Johnson County courthouse was built in 1882. In 1841, nearby Franklin College was the first Indiana college to admit women, but its male student body was so depleted by Union Army enlistments that the school was forced to close for five years.

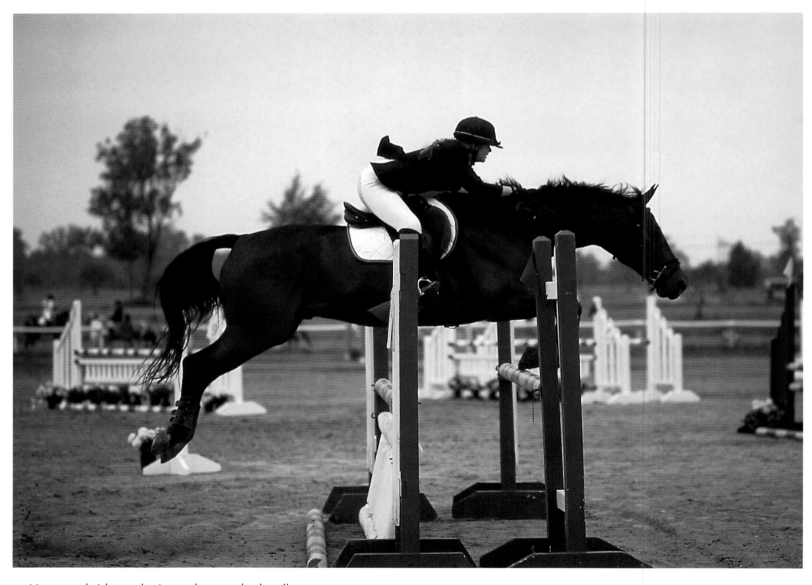

△ Horse and rider make it neatly over the hurdles at the Hoosier Horse Park in Johnson County, where both English and Western events are held. The state legislature legalized pari-mutual betting in 1989, and thoroughbreds have been racing at Anderson since 1994. ▷ Renovations of the classic Corinthian-style state capitol have cost six times as much as the original $2 million construction cost in the 1880s. It is the centerpiece of a complex of modern Indiana government buildings in revitalized downtown Indianapolis.

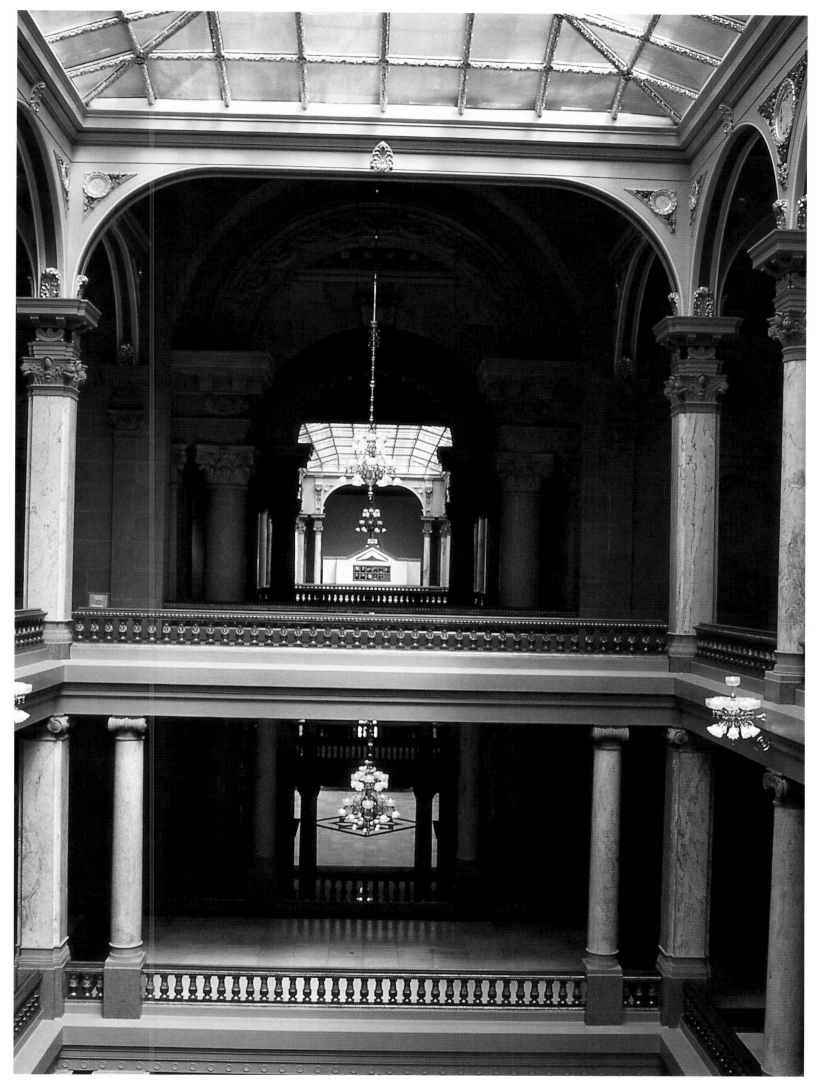

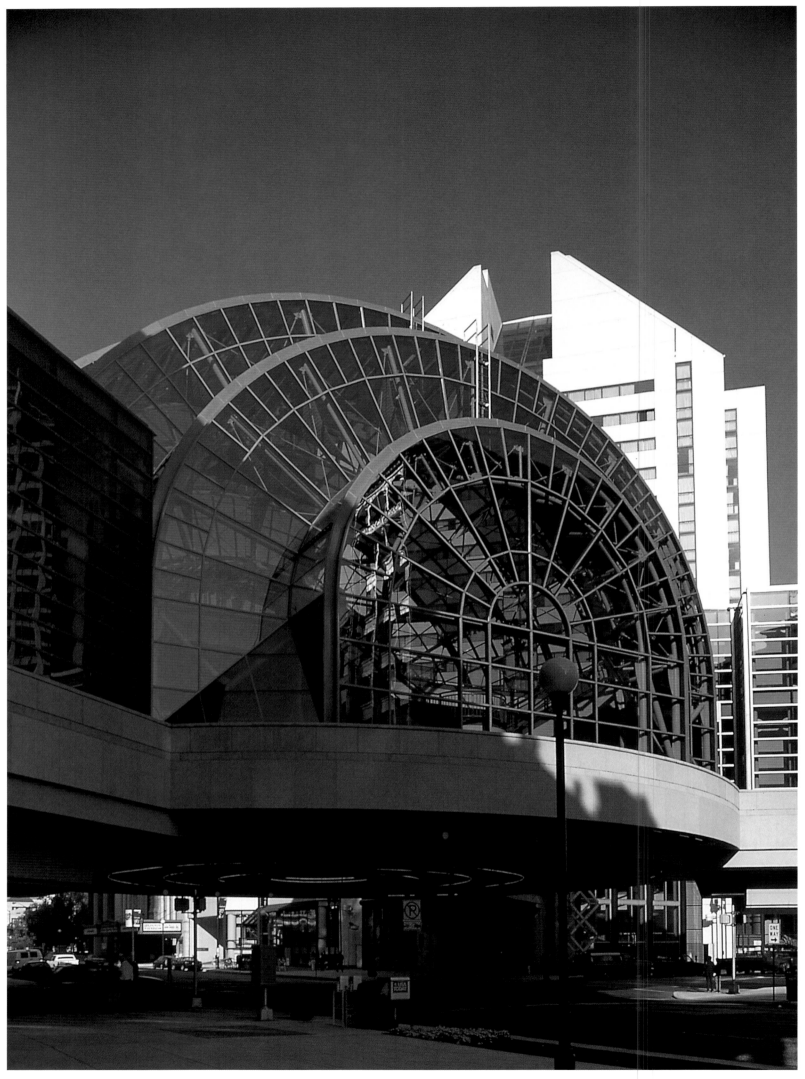

◁ Spanning a downtown intersection, the Artsgarden
provides a well-lighted open space for theatre, dance,
music, and exhibits scheduled by the Arts Council of
Indianapolis. It is a part of the new Circle Centre at
the heart of the capital city. △ A rainbow arcs over
Marion County treetops. ▷▷ Cedar trunks imported
from British Columbia support this portico of the
Eiteljorg Museum of American Indian and Western
Art, but the sandstone and dolomite building was
designed to suggest the pueblos of the Southwest.

83

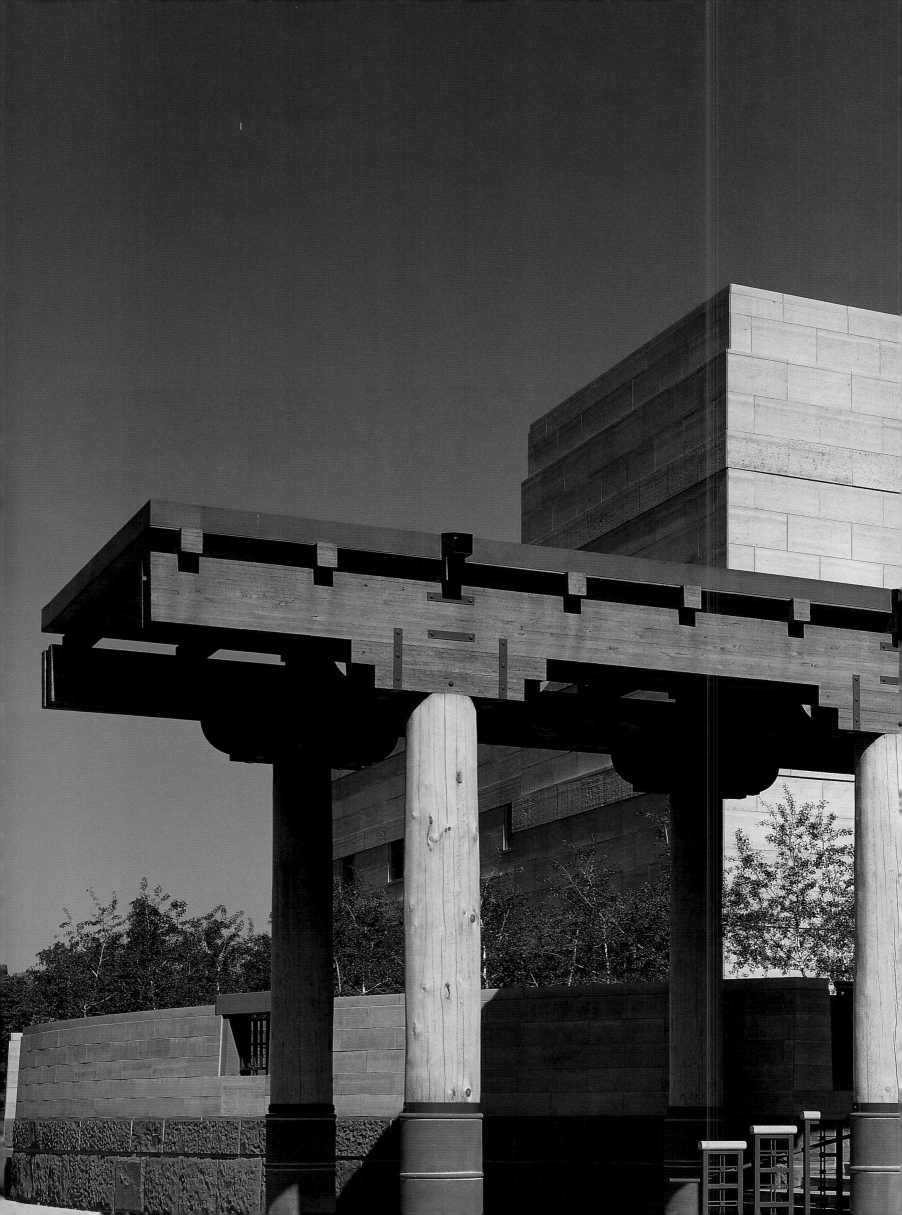

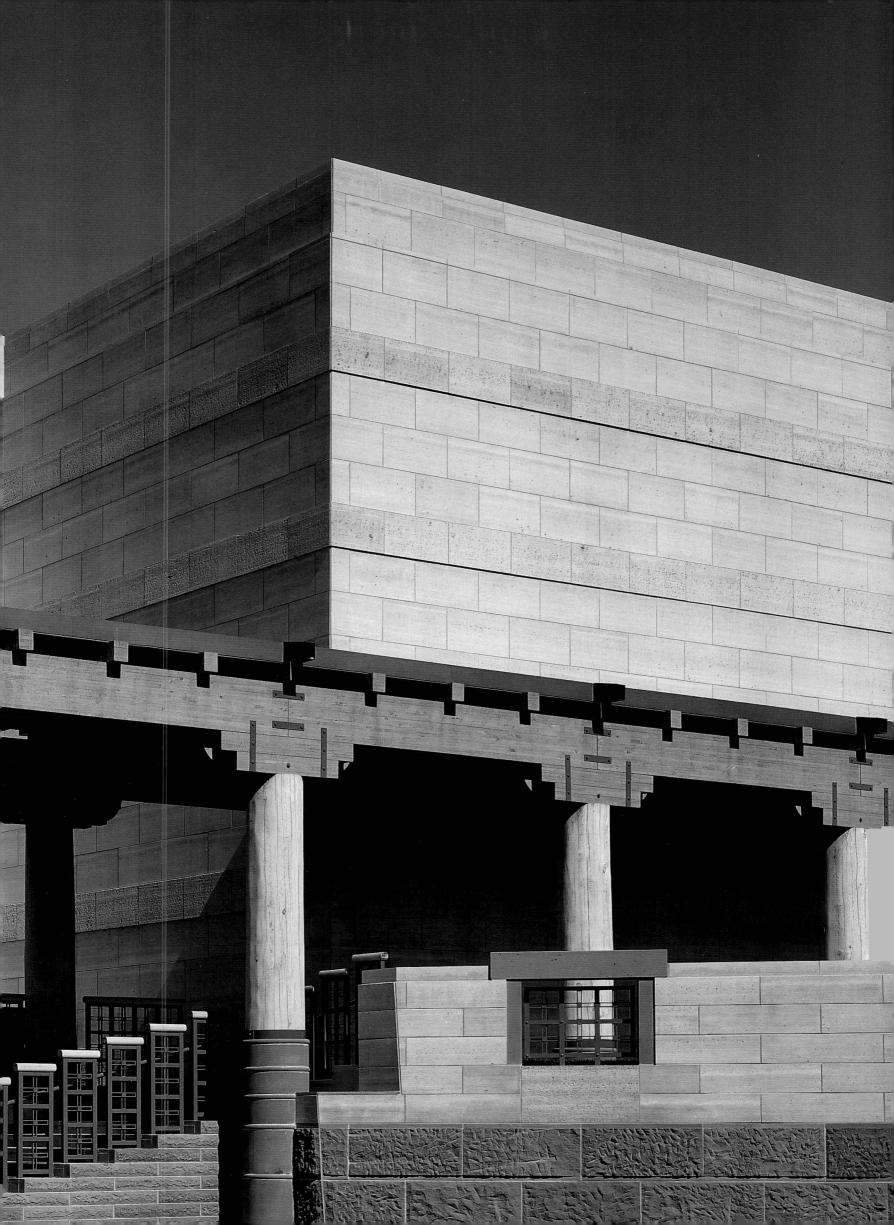

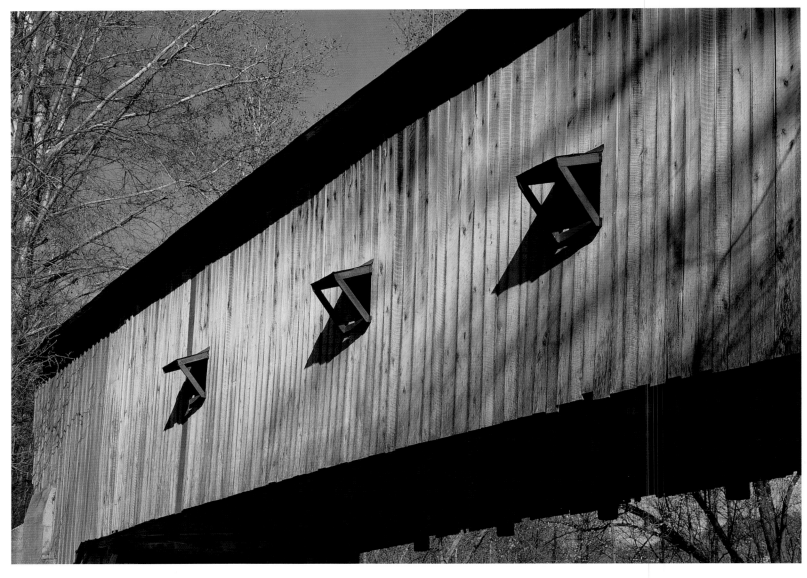

△ Automobile traffic still crosses this wooden covered bridge in Hendricks County, a largely agricultural county just west of Indianapolis. In 1948, a tornado roared through the county, killing twenty persons and obliterating the little town of Coatesville. Improved tornado warning methods that have grown out of that tragedy have surely spared many lives in the ensuing years.
▷ Irises blooming along the margin of an Owen County pond brighten a calm spring day.

△ Expanses of intense yellow seen from county roads prove at closer view to be wild mustard, as in this Owen County field. Although oil from the mustard seed provides the flavoring for the popular hot dog condiment, it is not always grown as an intentional crop. Under certain weather conditions, the dormant mustard takes over whole fields between corn plantings. Despite its beauty and limited commercial value, farmers often consider mustard to be just another weed.

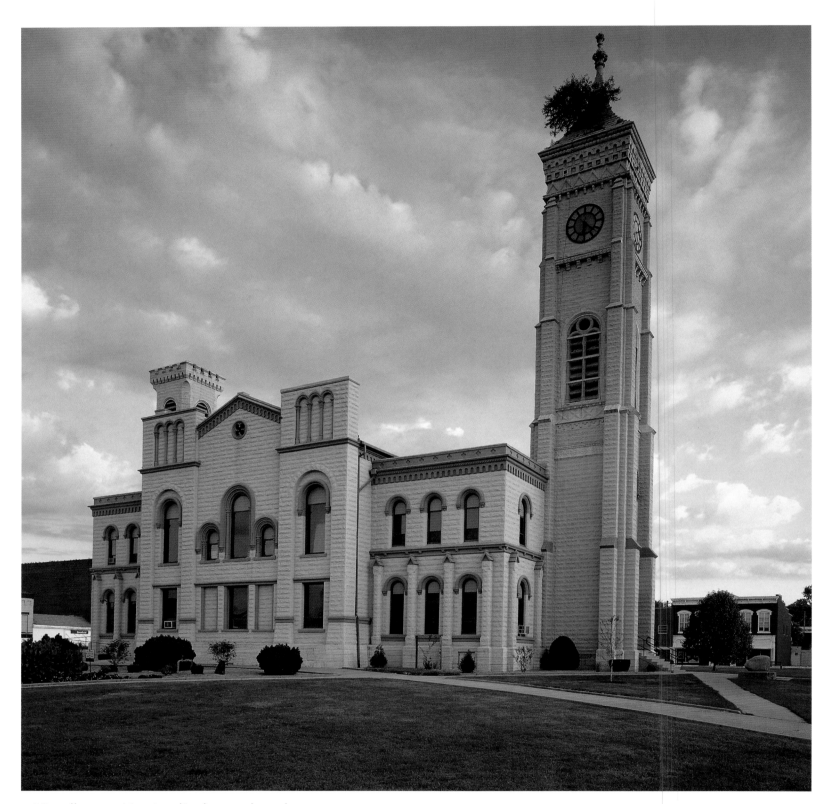

△ Virtually every Hoosier alive knows about the tree
in the tower of the Decatur County Courthouse at
Greensburg, which is so proud of it that its nickname is
"Treetown." A lithograph in 1882 showed branches
sprouting from the tower of the 1860 structure. This is
not the original tree. ▷ Veedersburg began as a mill
town, then became a brick-making center and now has
a casting foundry. The town is near the edge of Indiana's
coal fields, in Fountain County—another of Indiana's
counties named after men killed in the Indian wars.

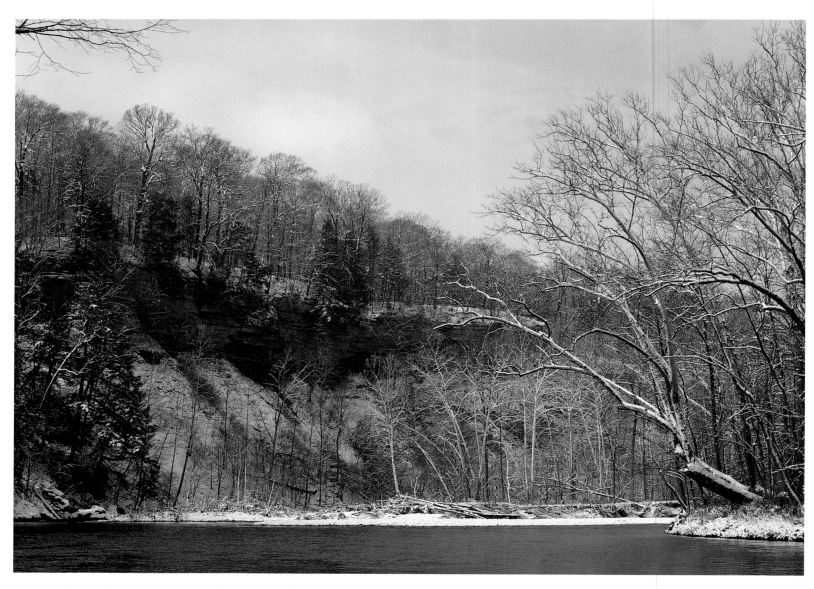

△ Sugar Creek flows under one of the rugged cliffs that make Shades State Park, in Montgomery County, a favorite place for hikers. The name's origin is murky, but tradition says early settlers likened the deep-woods gloom to the "shades of death." Terrain features bear such names as Devil's Punch Bowl and Lover's Leap, perhaps indicating the settlers' state of mind as they moved into this formerly Piankeshaw Indian country. ▷ A bee's-eye view shows a glorious clematis flower. Native Indiana varieties are twining climbers with a deep, urn-shaped blossom.

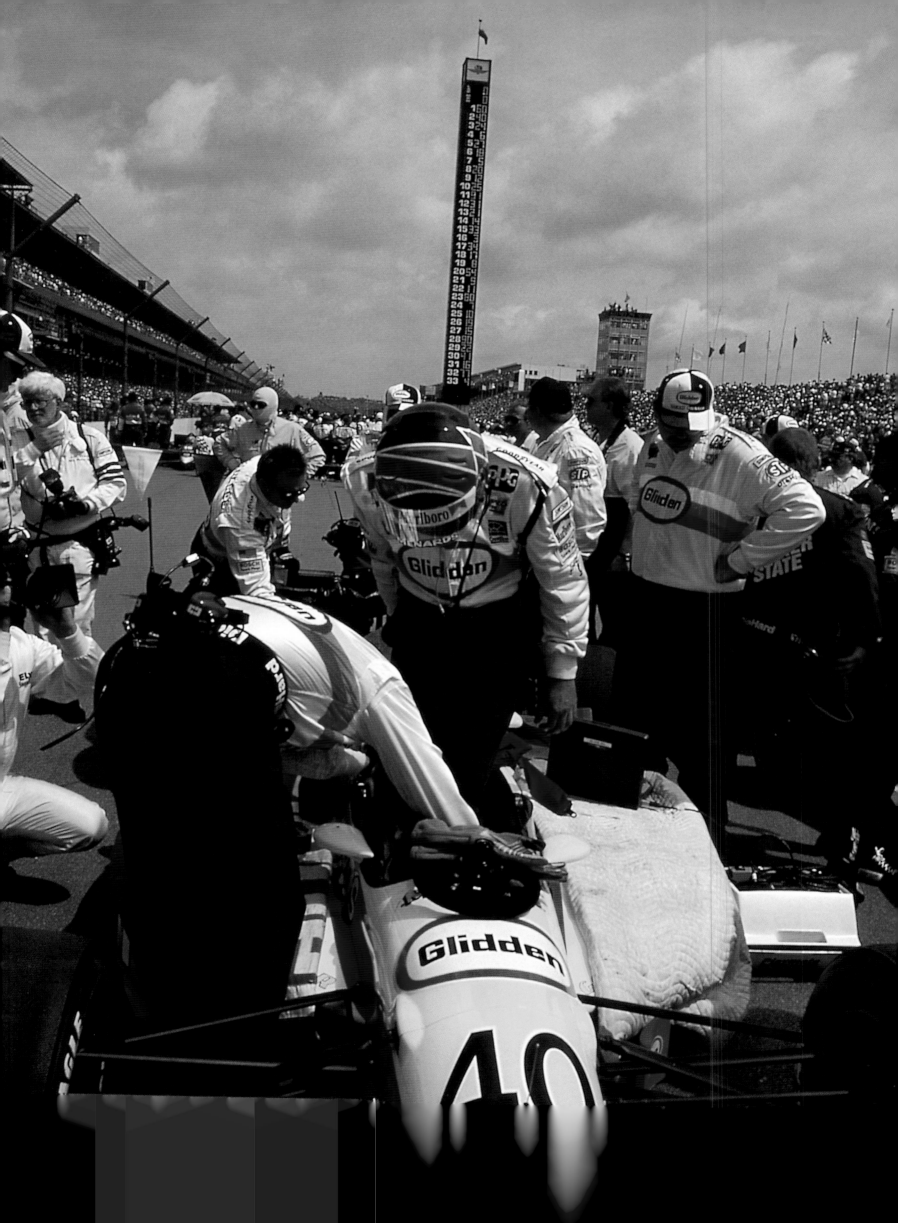

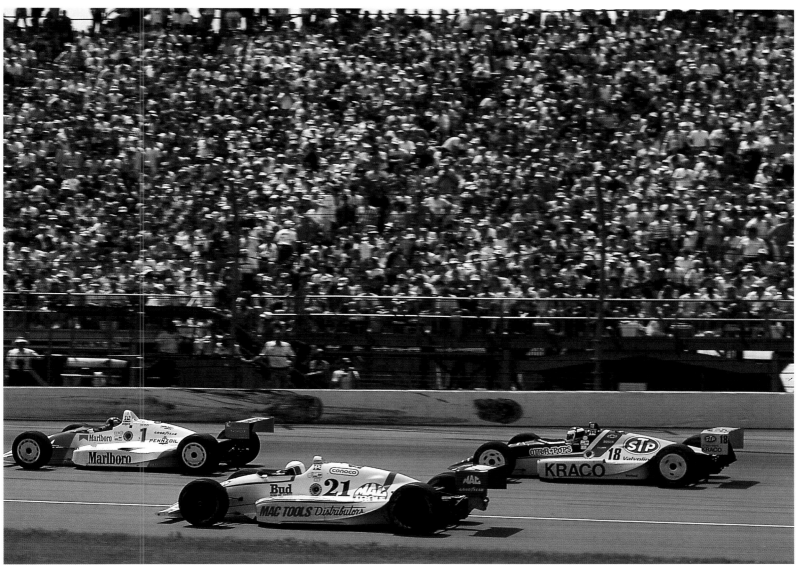

◁ Shortly before the big moment, a front-row driver squeezes into the form-fitting cockpit of his race car at the Indianapolis Motor Speedway. Some of these veteran drivers raced at a Michigan track instead of Indy last Memorial Day weekend, protesting a new eligibility rule by Speedway management—a bump in the long road of '500' traditions, which fans hope will be smoothed over by next year's race. △ The crowd is on its feet for the thundering, snarling first lap, in which drivers try to gain advantageous positions for the long run.

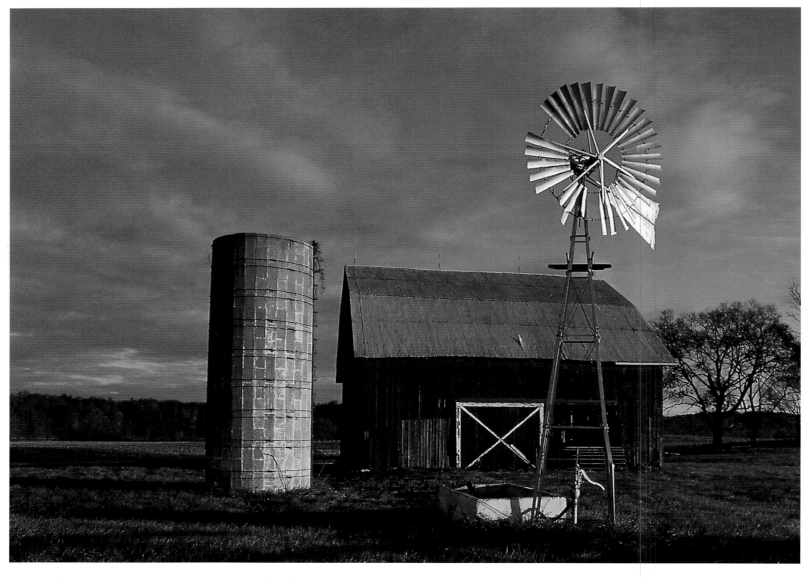

△ An old-fashioned water-pumping windmill still
stands at Whitaker. Motorists traveling southwest
here from flatland Indianapolis begin seeing the
hills of the part of the state that was not ground
down by Ice Age glaciers. ▷ Hay barns are rainy-
day playgrounds for rural youngsters. Swinging,
leaping, making tunnels among the sweet-smelling
bales, or just lying in loose, fragrant hay with
an adventure book—all are joys city kids don't
know unless they have country relatives to visit.

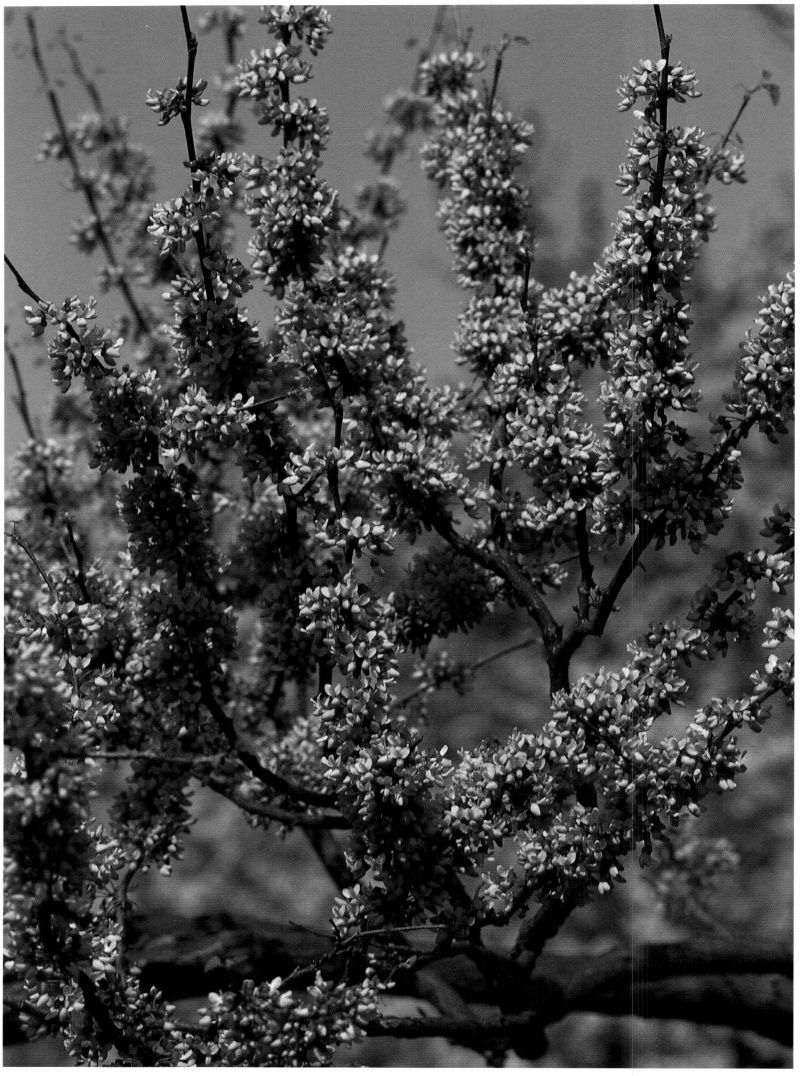

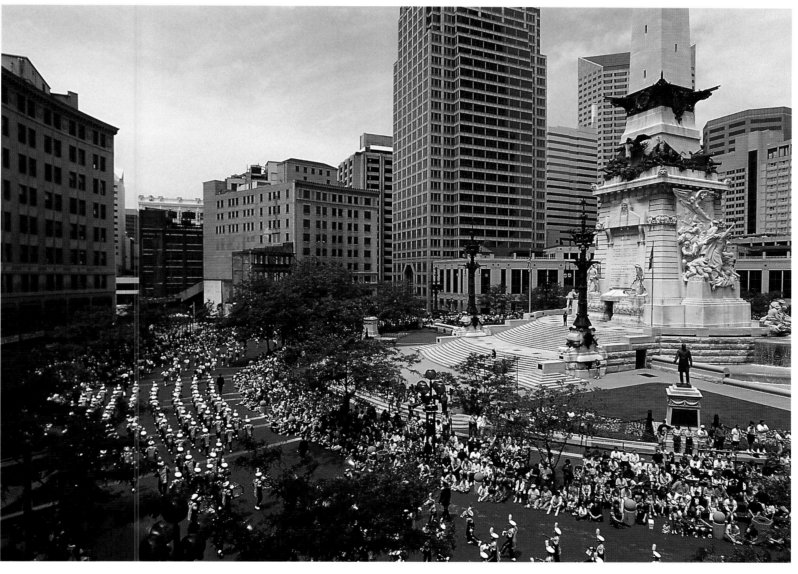

◁ If anything can compete with the beauty of autumn's turning leaves, it is the blossoming of the redbud trees in April and early May. Coinciding with the showiness of the flowering dogwood and the early budding of deciduous foliage, they can make a Hoosier hillside appear covered with clouds of pink, white, and emerald pastel dust. △ Purdue University's Marching Band struts around Monument Circle, the grandest part of the route of the "500" Festival Parade through downtown Indianapolis.

△ Long a true "low profile" city without skyscrapers, Indianapolis now seems to have a new one every time you go downtown, many of them bold and innovative architectural designs, not just tall boxes. Intermixed with the office towers and sports facilities that shot up in the 1980s are numerous old classic architectural landmarks. ▷ It is almost impossible to trick a Conner Prairie historical interpreter into uttering an anachronism; they are there to convince you that they live in the early nineteenth century.

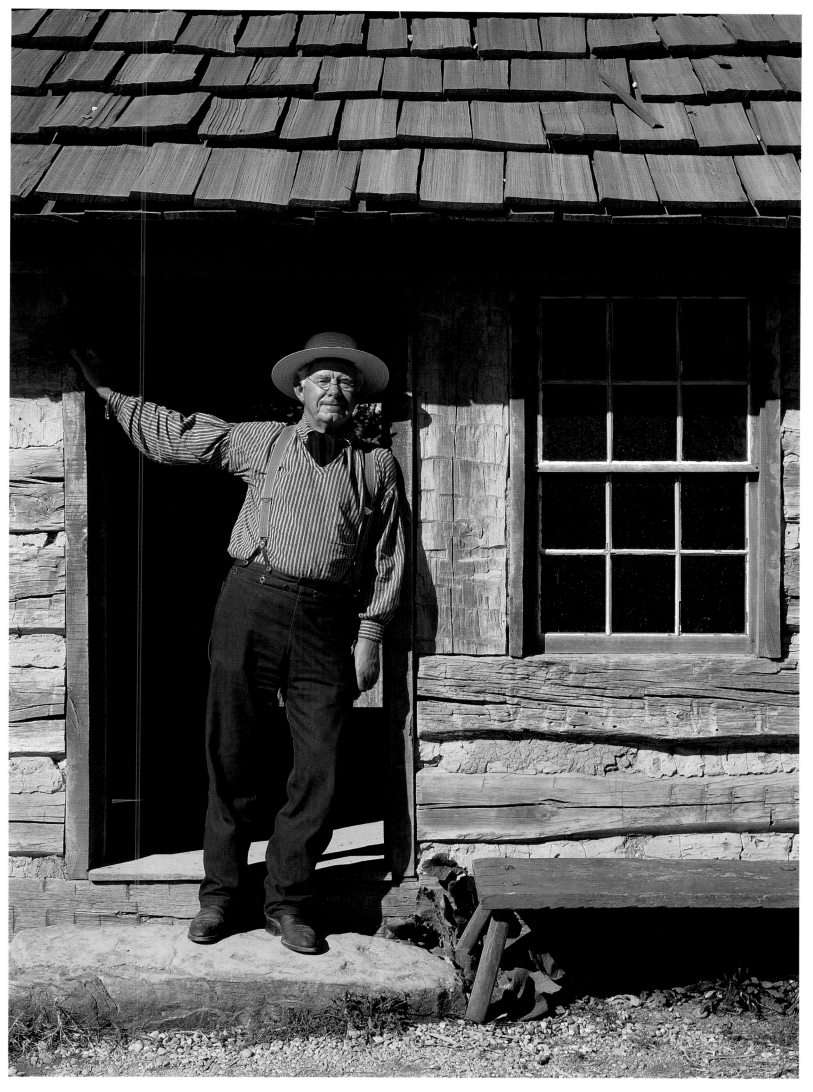

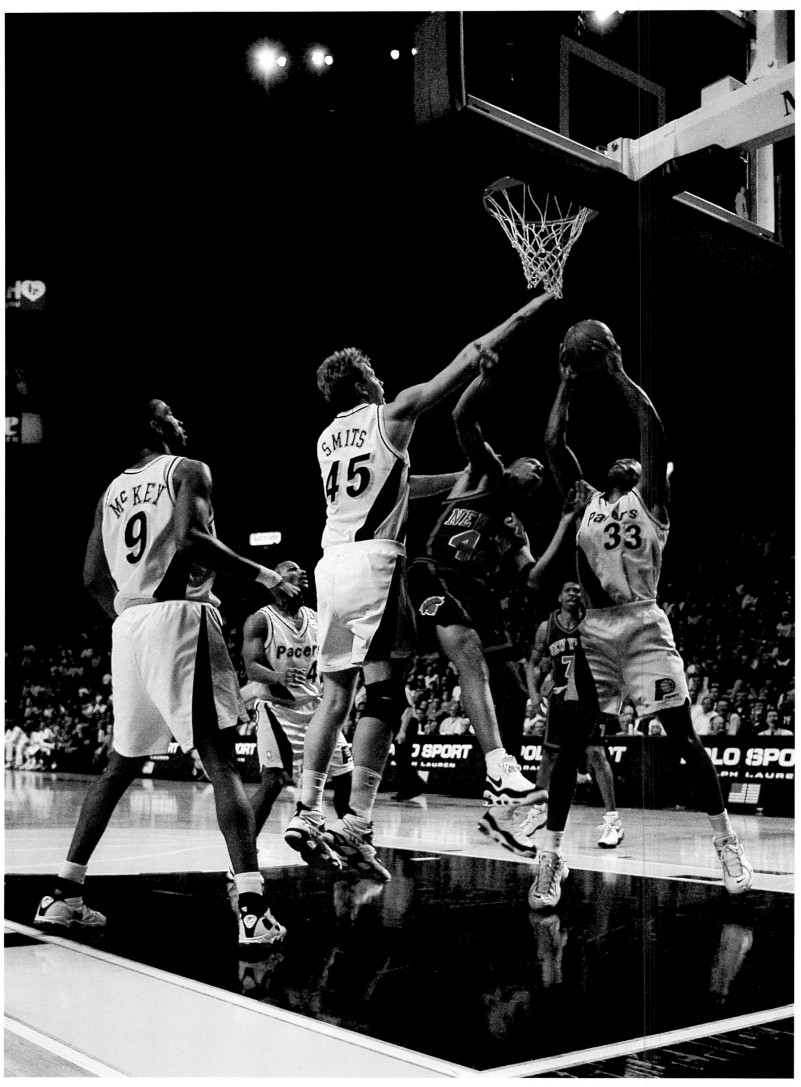

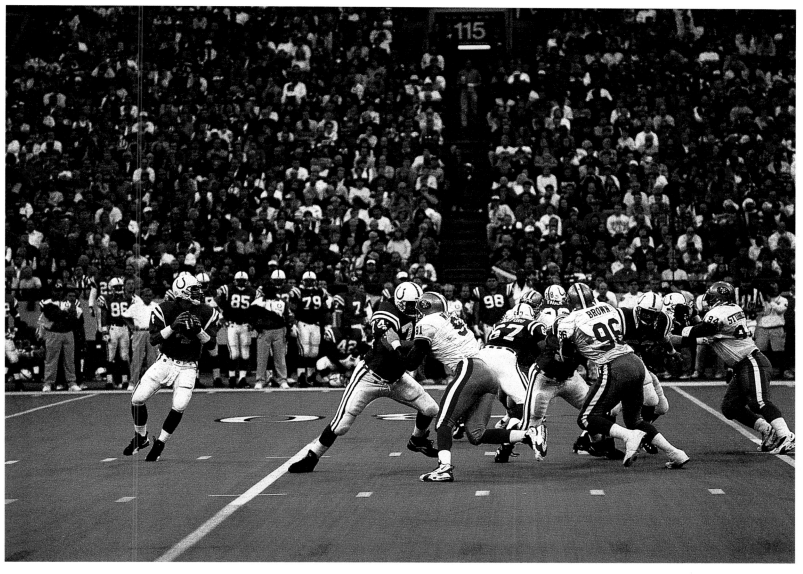

◁ Professional basketball has a prominent place in a state where kids learn to dribble as soon as they outgrow drooling. The Indiana Pacers make their home in Market Square Arena, one of America's biggest sports arenas.

△ Baltimore Colts fans sneered at the name "Indianapolis Colts" when the pro football team moved to the Hoosier capital in 1984 and made its home in the new $82 million Hoosier Dome Stadium (since renamed the RCA Dome).

▷▷ These hay bales were harvested on farmland reclaimed from a strip mine in the coalfields of western Indiana.

103

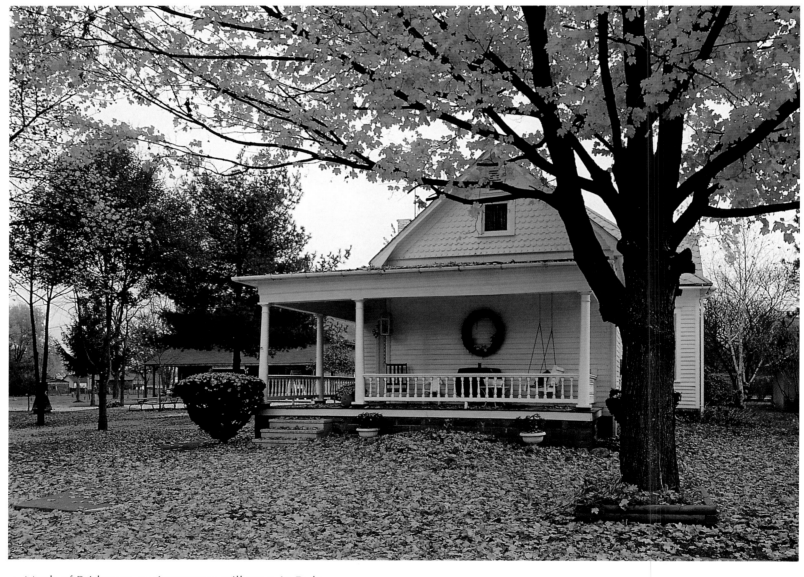

△ Much of Bridgeton, a picturesque mill town in Parke
County, has retained its turn-of-the-century look, includ-
ing this modest residence, and the red-frame Bridgeton
Country Store, where goods are still sold over counters
a century old. ▷ A family of Brahma cattle get along
amiably in an Owen County pasture. ▷▷ This small
pond on the photographer's land in Owen County attracts
waterfowl and provides a splashy playground for his
water-loving dogs, as well as a natural studio for pho-
tographing the ever-changing effects of light on water.

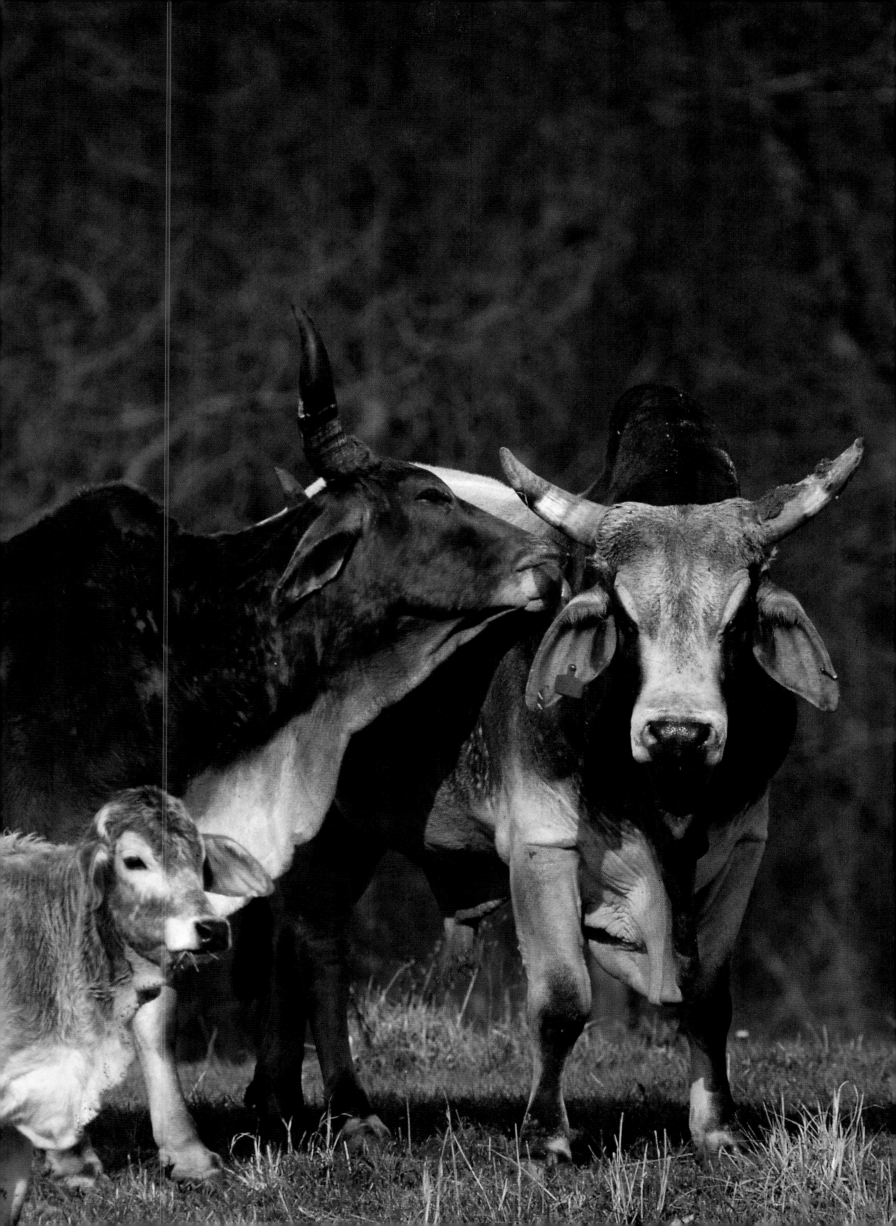

◁ This brick house in the historic Lockerbie
Square District of downtown Indianapolis was the
home of Hoosier Poet Laureate James Whitcomb
Riley during the last twenty years of his life,
though he did not own it but was a paying guest.
△ Founded by German immigrants as a cultural
and gymnastics club to maintain their Old World
traditions, the Athenaeum Turners is Indianapolis'
original building; anti-German bias in World War I
changed its name from *Das Deutsche Haus.*

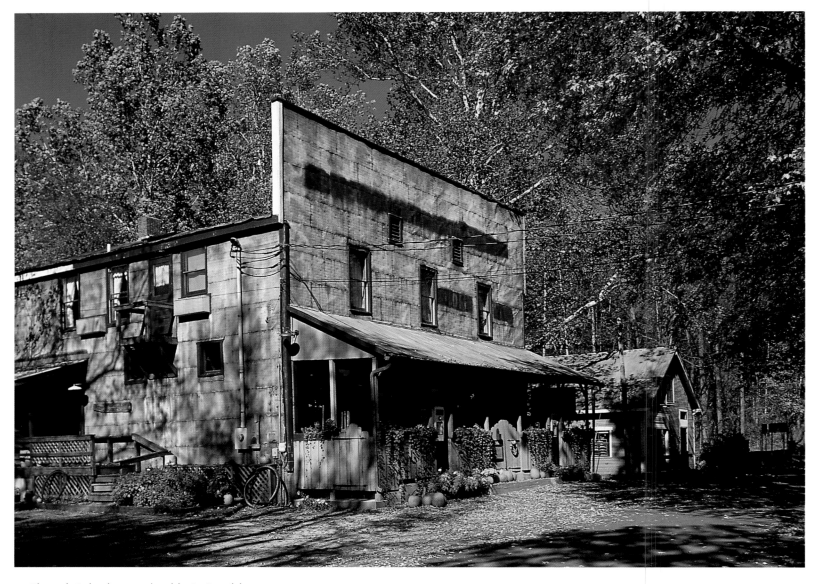

△ Though it looks ramshackle in its old country-store structure, the Story Inn, at a bend of State Road 135 in Brown County, has good lodgings and meals that Hoosiers will drive across the state for, when they have the leisure time. ▷ This fall scene in Brown County looks toward the Hoosier National Forest. The southern Indiana hills are high and steep, but the far horizon is level, because even the hill country was once flat; ancient Mississippian Age sea bottoms became a peneplain, which was then shaped by millennia of erosion into ridges and gullies and valleys.

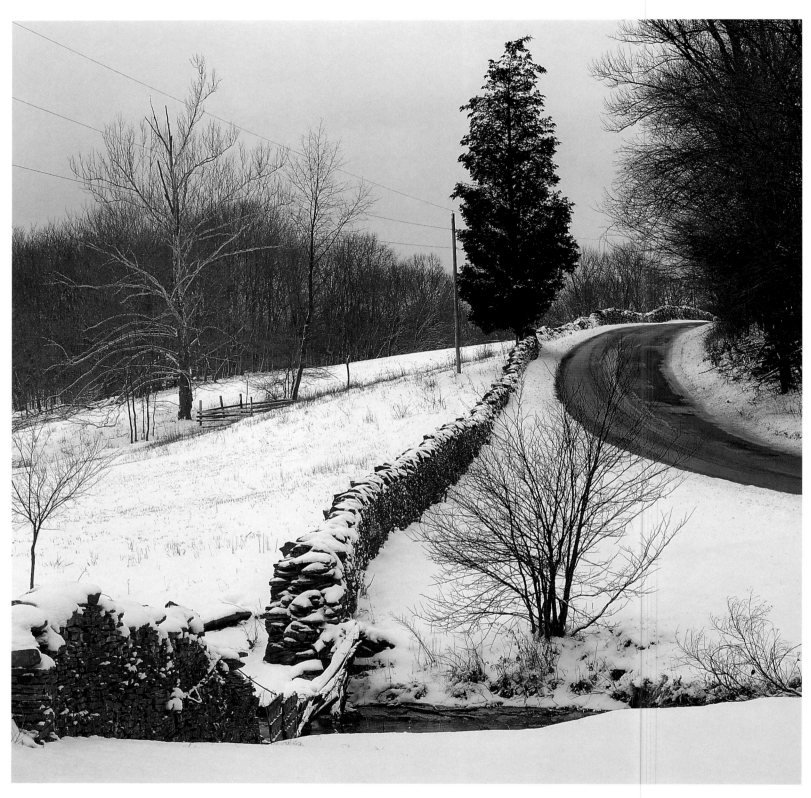

△ Miles of unmortared stacked-stone fences line fields in a
hilly area west of Bloomington. Basically a New England
technique, such fencebuilding is rarely seen in Indiana.
▷ Without mountains or seacoasts to gaze upon, Hoosiers
learn to enjoy the more subtle and evanescent beauties
of nature, such as sunset skyscapes, seasonal changes,
flowerings, and harvests—even a stretch of bright, dry
weather. A photographer from California once moved to
Indiana but left at once, saying, "There's nothing to shoot
here!" He didn't take time to see with Hoosier eyes.

△ This tree at Green's Bluff Nature Preserve in Owen County is believed to be the oldest hemlock in the state. The hemlock stand at the preserve is rare, most hemlock woods having been taken long ago for the tannin in their bark. ▷ Standing on the pedals, bicyclists in the Hilly Hundred race know how steep the southern Indiana hills really are. Some five thousand riders participate in the two-day October event, doing fifty miles a day on a course through Morgan, Monroe, and Brown Counties.

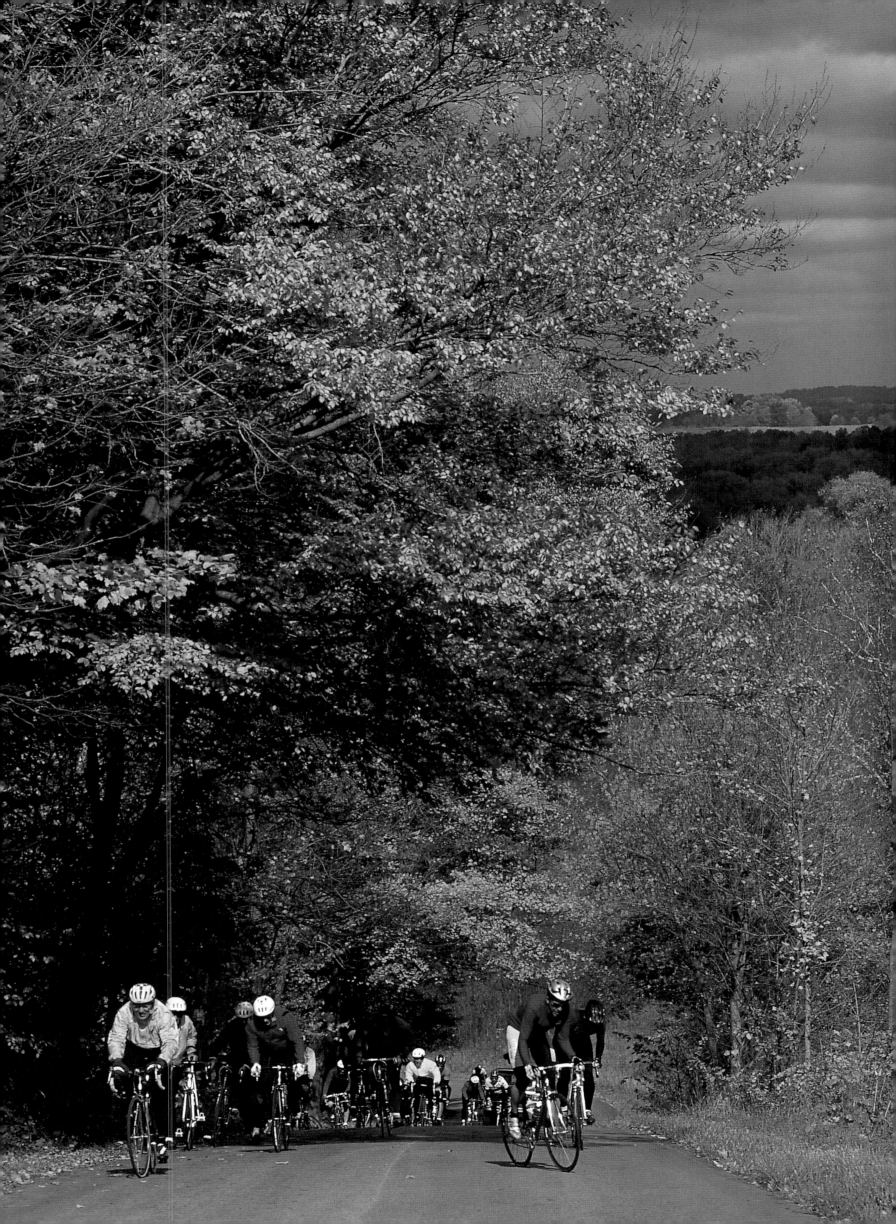

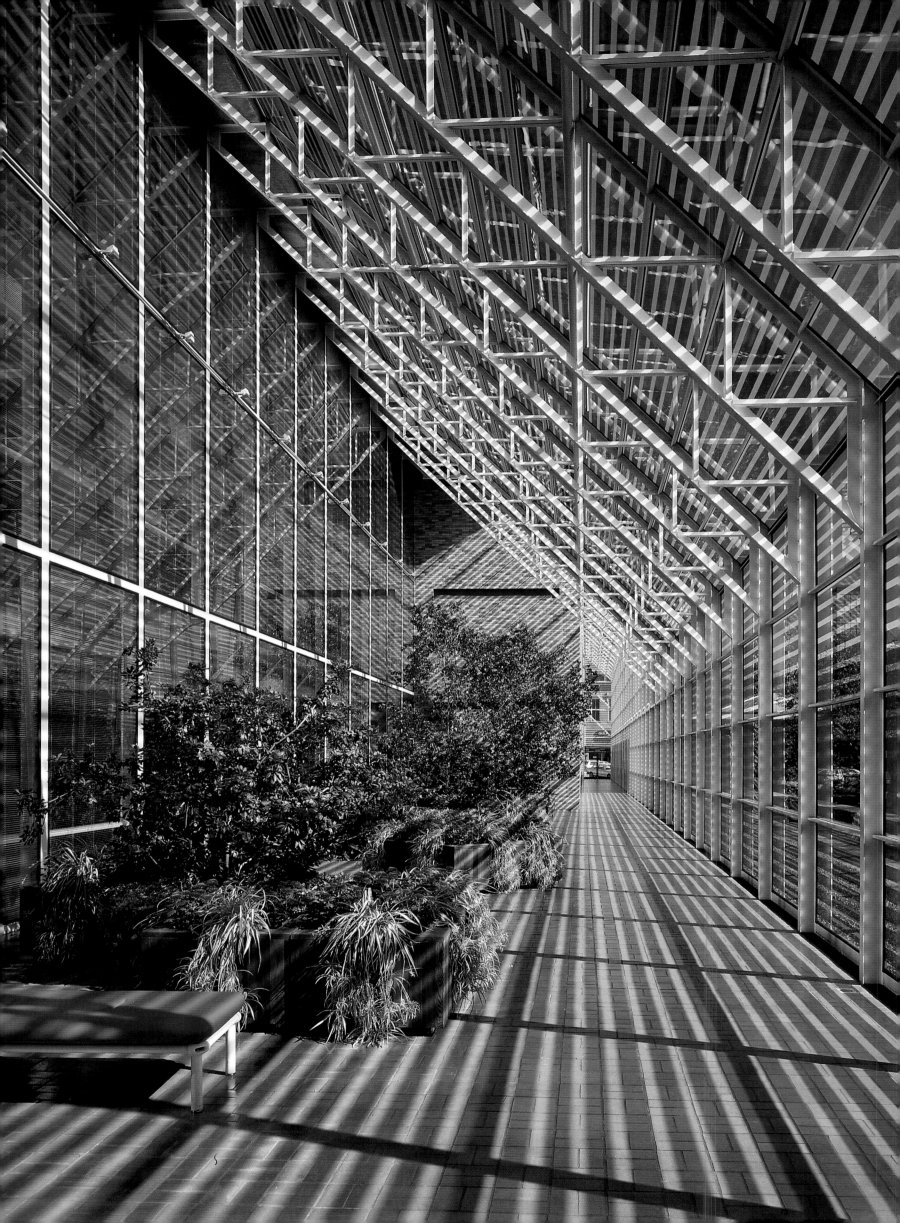

◁ This three-story addition to the Irwin Union Bank and Trust Company at Columbus is one of the town's more than fifty structures designed by world-class architects. This phenomenon began when J. Irwin Miller, chairman of the Cummins Engine Foundation, offered to pay architects' fees for the best possible public buildings, churches, and schools. △ Down in the very "toe" of southwestern Indiana, Hovey Lake is a stopover for migratory birds, and supports one of the northernmost stands of bald cypress trees in America, as well as this profusion of lotus.

119

△ A true harvest moon rises over a field of corn ready for
the combine. This grain, developed in many strains by
early Native Americans, was America's greatest food gift to
the rest of the world; it is processed into cereals, cooking
oils, syrups, and snack foods, and made into whiskey and
livestock feed. Indiana produces nearly a billion bushels a
year. One Hoosier firm is using cornstalks as pulp for
paper-making, an experiment to save trees. When gasoline
prices rise, corn farmers start thinking of the market for
gasohol, gasoline blended with alcohol made from corn.

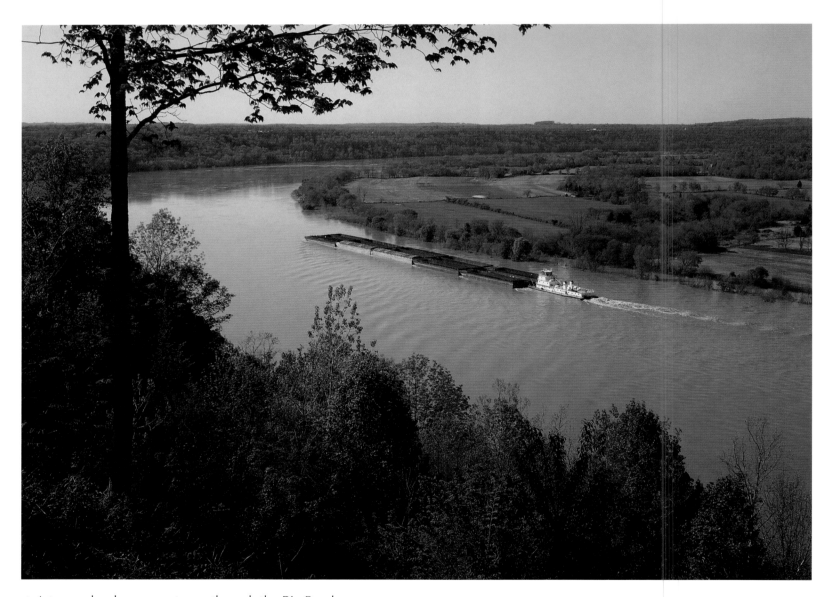

△ A tug pushes barges upstream through the Big Bend
of the Ohio River near Leavenworth, Indiana, a ten-mile
looping meander which nets river traffic a mile of progress
as the crow flies. The Ohio was a main water transporta-
tion route for ancient mound-building Indian cultures hun-
dreds of years before the arrival of Europeans. ▷ Downy
gentian blossoms unfold in humid morning air; nectar in
the vase-shaped flowers will attract pollinating insects.
▷▷ Creekwater trickles over limestone strata just above the
falls of McCormick's Creek State Park, the state's oldest.

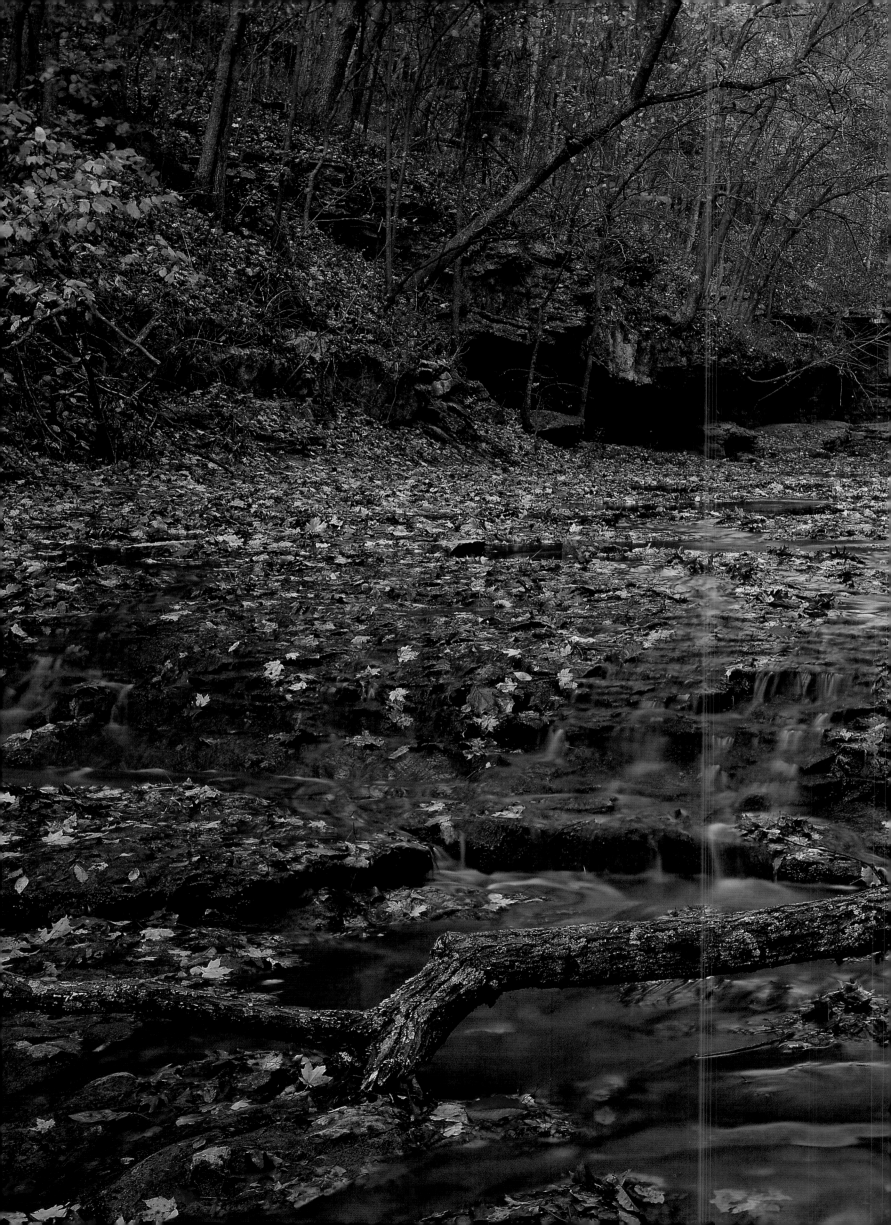

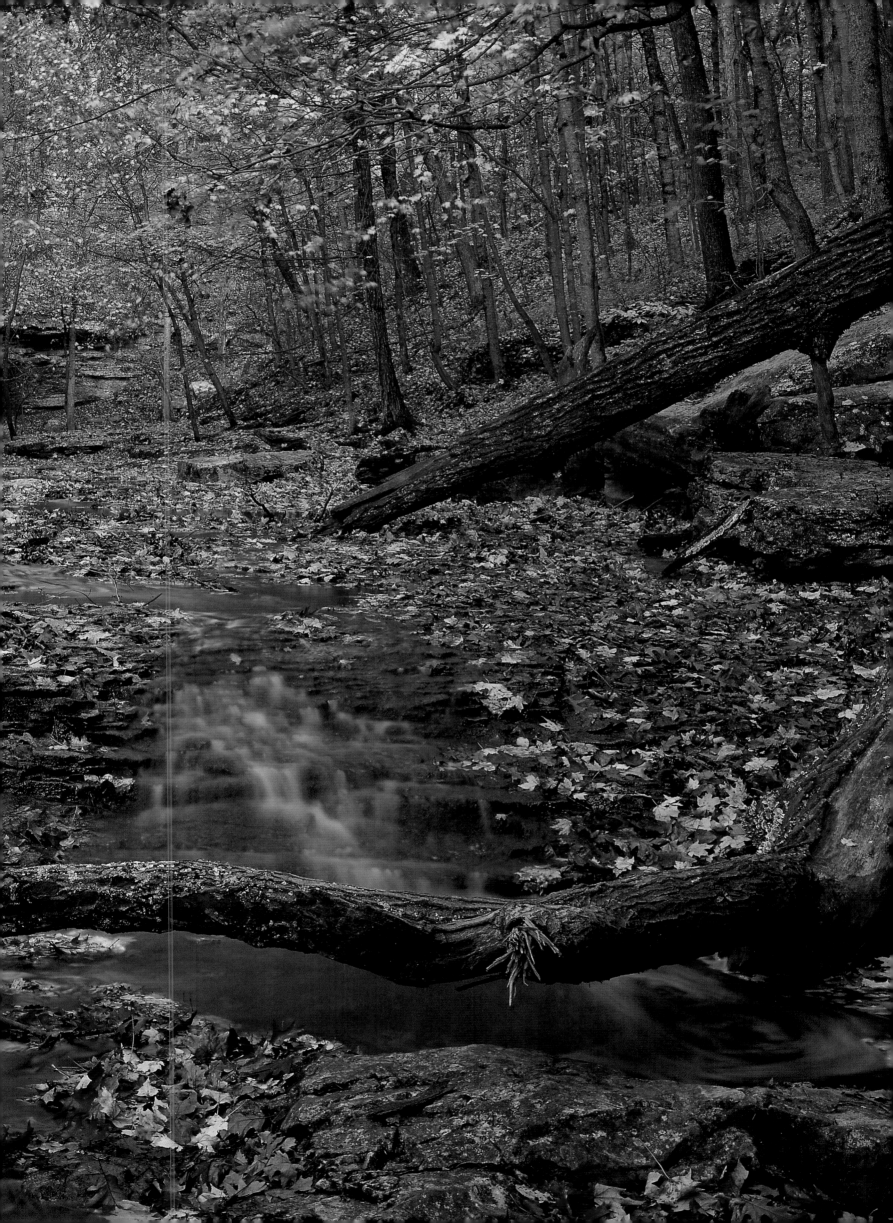

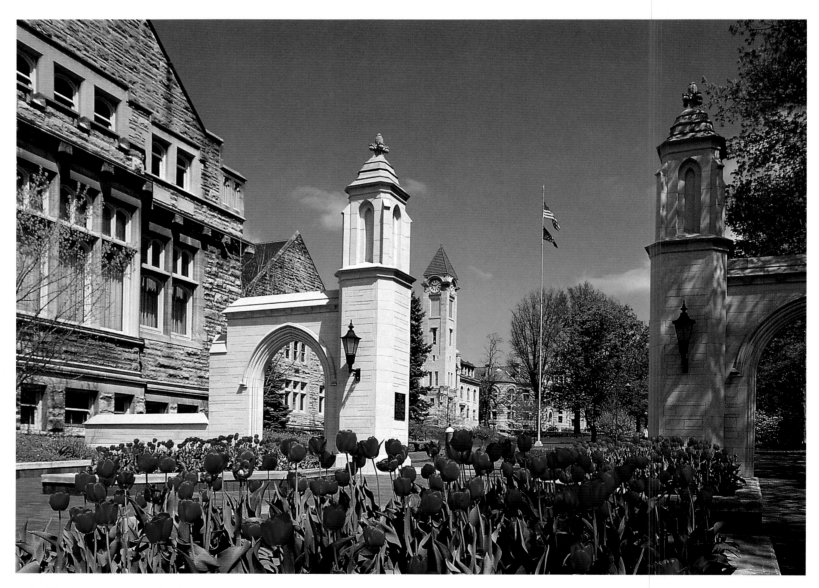

△ Inside the west gate of Indiana University's main campus at Bloomington stand some of the campus's oldest buildings, including a clock tower rebuilt after a recent fire. One of the country's largest state universities, I.U. was conceived when the territorial legislature petitioned for statehood in 1815, and opened ten years later as a state seminary. The town's name derived from the profusion of wildflowers in its upland valley. ▷ Clifty Creek cascades down a limestone gorge on its way to the Ohio River Valley, just west of Madison, a beautifully preserved old river port.

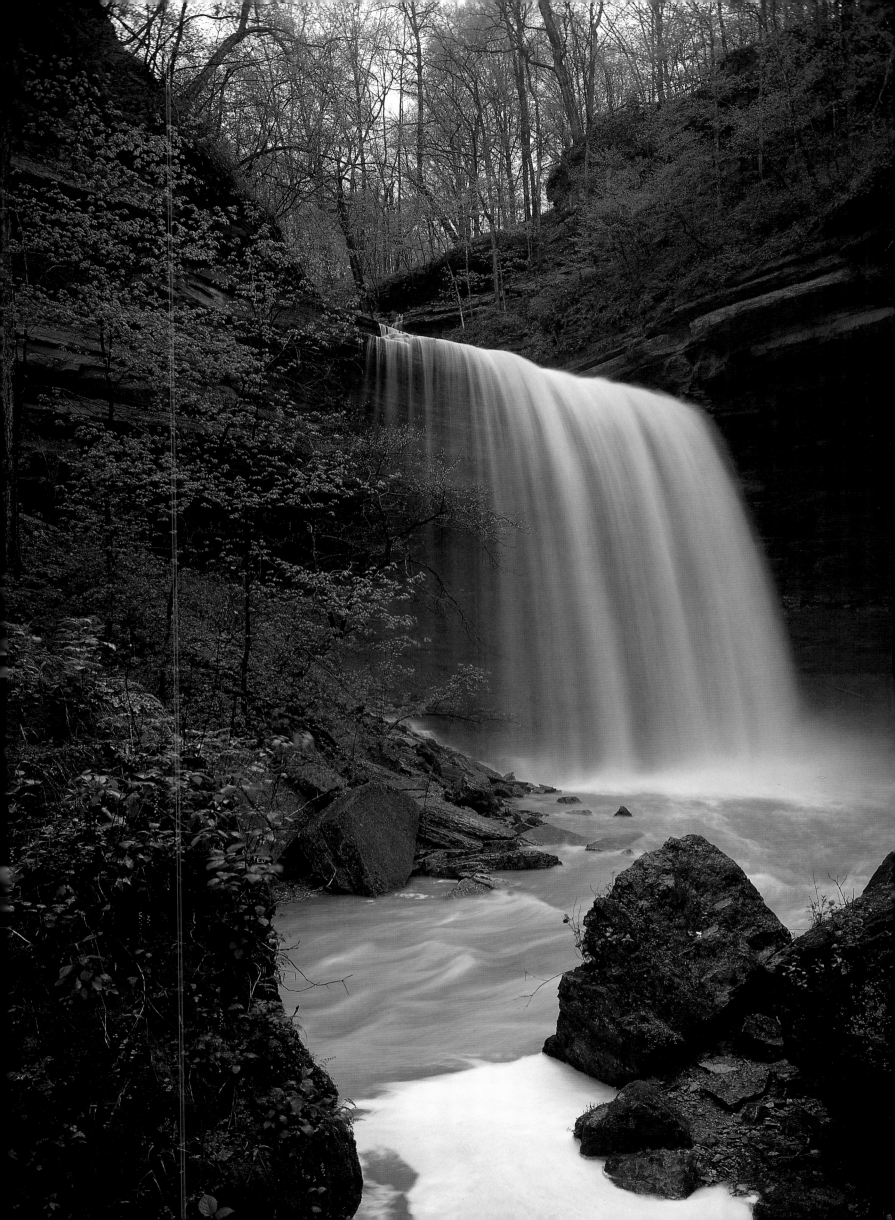

◁ The Culbertson Mansion in New Albany, across the Ohio from Louisville, is one of the valley's finest mansions. Its woodwork was done by boatbuilders who also made famous steamboats. △ The first Indiana state capitol was in Corydon in 1816, when most of the white population was scattered through the lower third of the state, but by 1820 a more northerly capital site was sought, which turned out to be Indianapolis, a hundred miles due north; in 1824 the seat of government was transferred up there in four wagons.

129

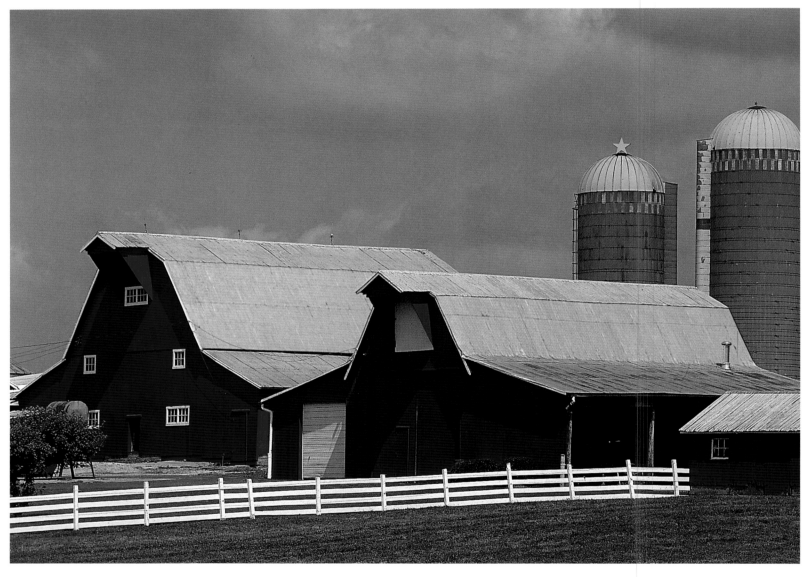

△ A huge but necessary part of a Midwestern farmer's
investment is in his barns and silos, and neighbors may
presume a lot about his well-being by the condition of
the structures. ▷ There is no law in Indiana that says
windows have to be installed plumb, and the builder
of this old farmhouse west of Ellettsville apparently
knew that. A magazine photographer from back East
once snapped this as a picture hinting at the drollness
of Hoosier character, along with such other examples
as a ten-foot-high rural mailbox marked "AIR MAIL."

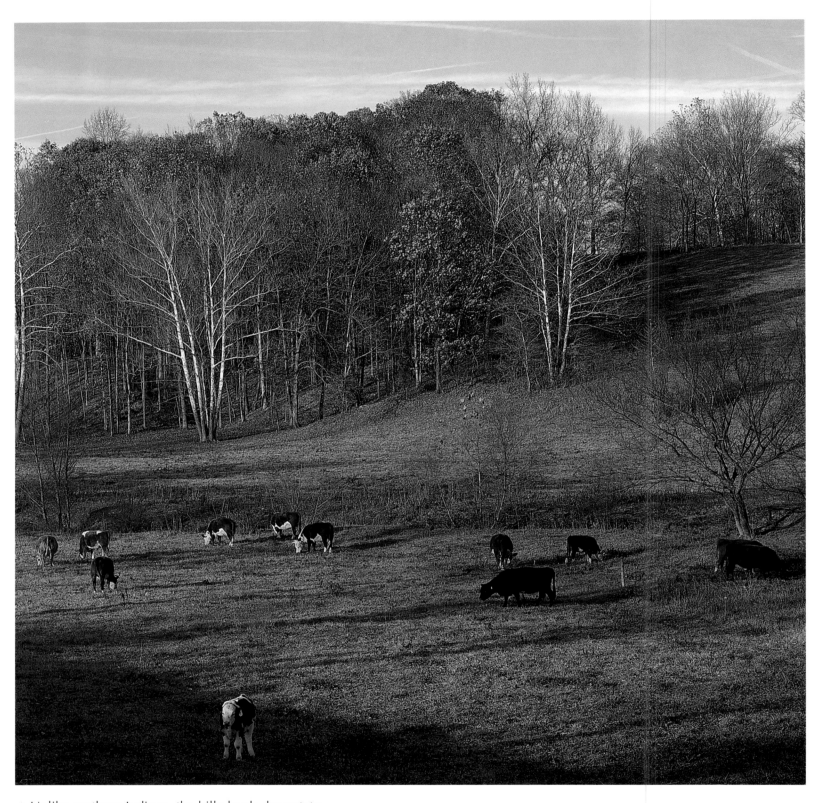

△ Unlike northern Indiana, the hilly lands downstate
don't lend themselves to the large-scale cultivation of
corn and soybeans, but farmers fit contoured crop-
lands into the rich creek and river bottoms, and use
a good proportion of their lands for hay or livestock
grazing. ▷ The state's Department of Transportation
has been reestablishing native grasses and wildflowers
along some roadside tracts, such as this one in Knox
County's Wabash Valley country, allowing Hoosiers
to see what was here before everything changed.

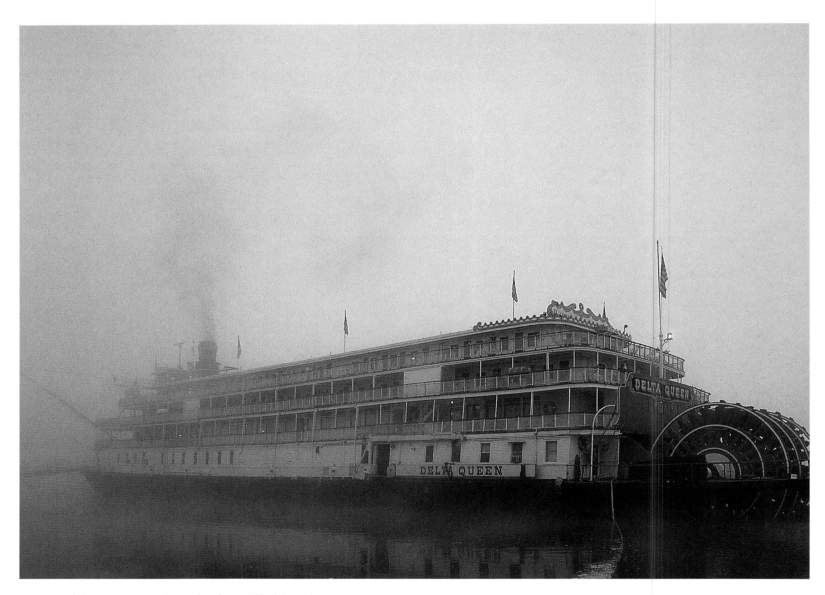

△ One of the excursion sternwheelers still plying the
Mississippi and Ohio, the *Delta Queen* looms in the mist
near the historic river town of Madison. ▷ Nineteenth-
century furniture and medical equipment of "horse-and-
buggy doctor" William Hutchings are on display in his
Victorian-era office and hospital at Madison. A passing
day-care teacher keeps her charges "on line." ▷▷ Abe
Lincoln slept here—when he wasn't sitting up studying
by firelight. The Great Emancipator lived in a log cabin
on this site from his seventh to his twenty-first year.

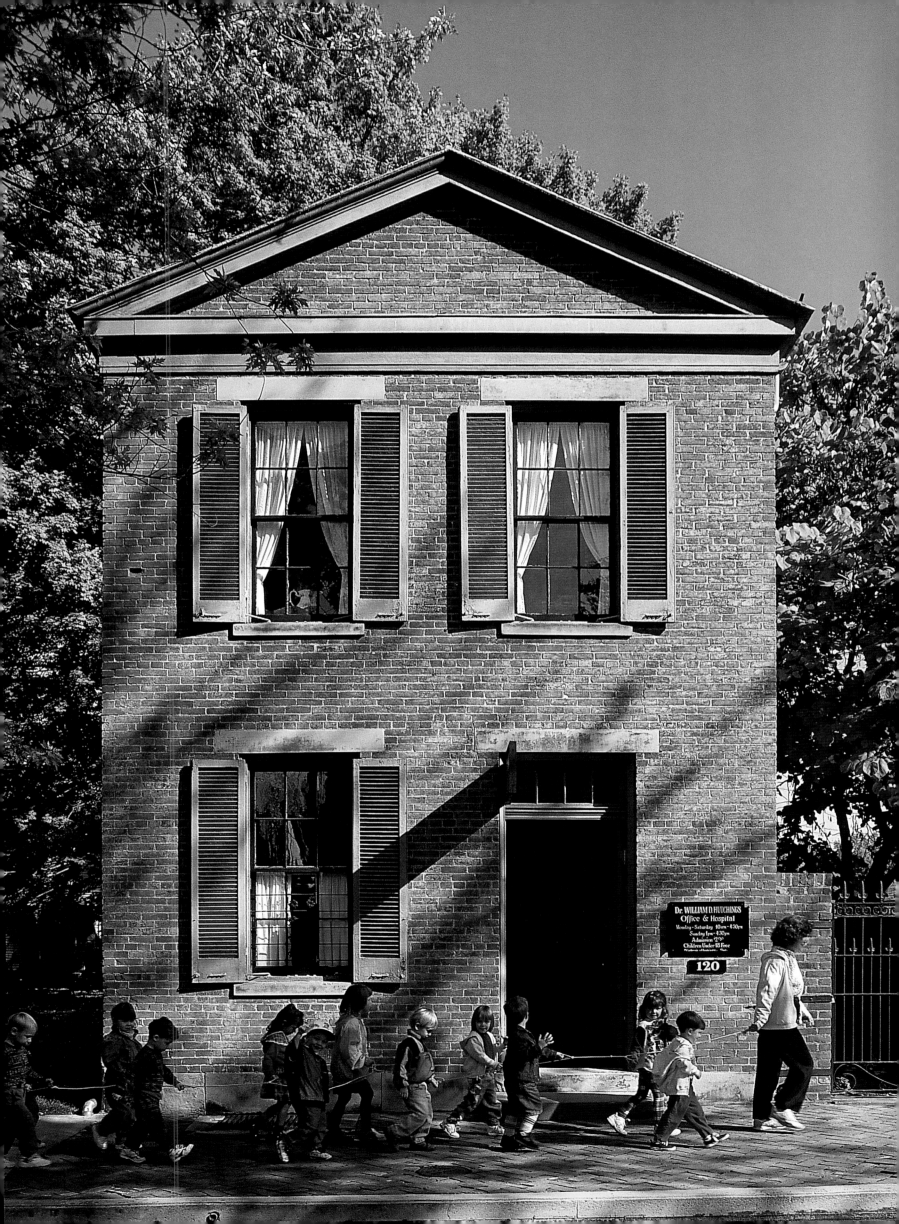

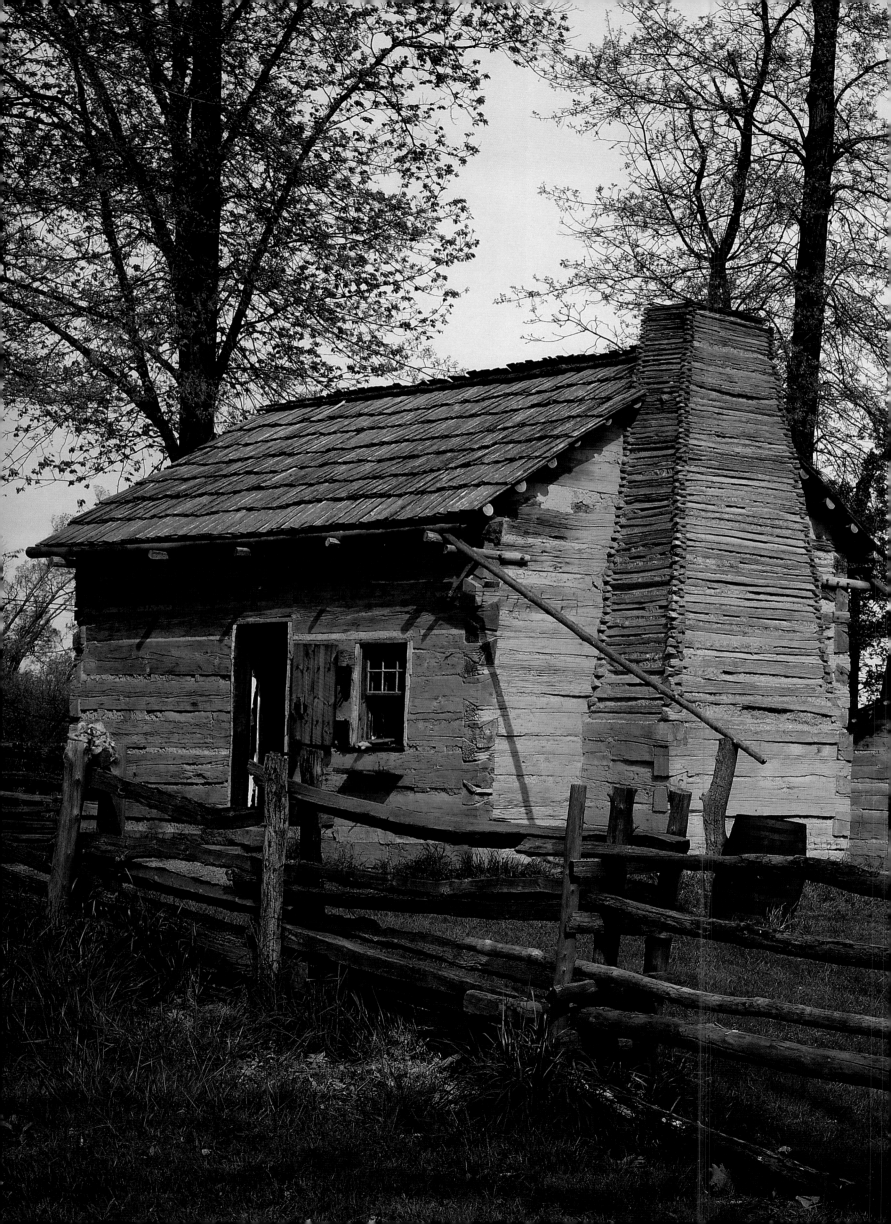

◁ A statue of Father Pierre Gibault, who helped
Colonel George Rogers Clark conquer the
Northwest Territory by swaying his French parish-
ioners to ally with the Americans, stands on a plaza
before the Old Cathedral of Vincennes, adjacent to
the national memorial to Clark. △ In 1853, Swiss
Benedictine monks arrived in Spencer County to
educate priests for Catholic settlement. Today, the
monks operate a multimillion-dollar mail-order gift
company to help support the St. Meinrad seminary.

139

△ The sun rises over the Ohio River at Rockport, where seven-year-old Abraham Lincoln was brought across from Kentucky by his father and mother in 1816. Though Lincoln was born in Kentucky and began his political career in Illinois, Indiana takes due credit for raising him. Here on the Indiana frontier, panthers screamed, bears killed the swine, and the poverty was "pretty pinching at times," he later wrote. In 1828, he started his first flatboat journey to New Orleans from Rockport.

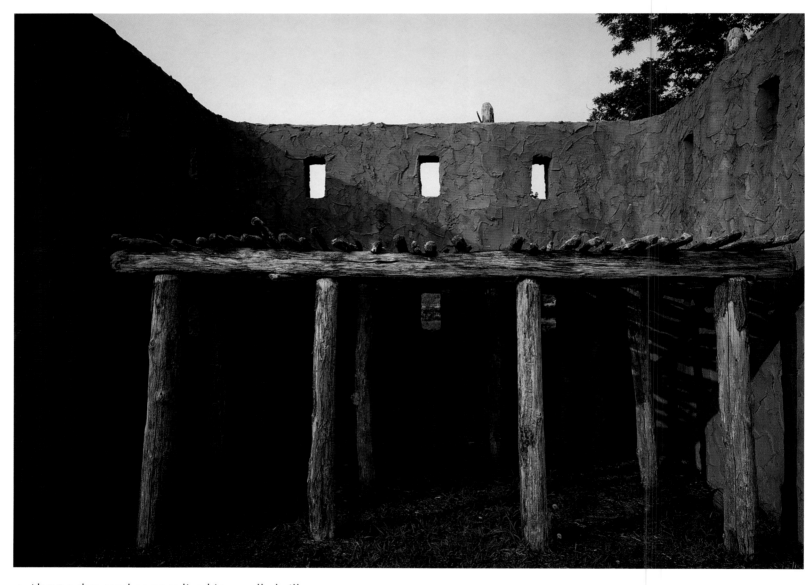

△ About a thousand persons lived in a walled village in the area of Angel Mounds State Memorial, near Evansville, for centuries before Columbus sailed to the New World. ▷ A leaf-littered road through the Owen-Putnam State Forest evokes the old paths Natives followed for thousands of years through the beautiful wilds of what came to be called Indiana—the Land of the Indians. ▷▷ Travel is easy now through the Indiana woods. The questions now are: "What will the twenty-first-century Hoosier be like?" and "Where is he going?"